WATERCOLOUR
MASTERCLASS

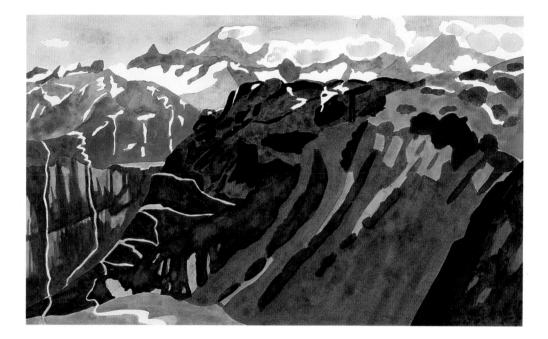

HarperCollins*Publishers*

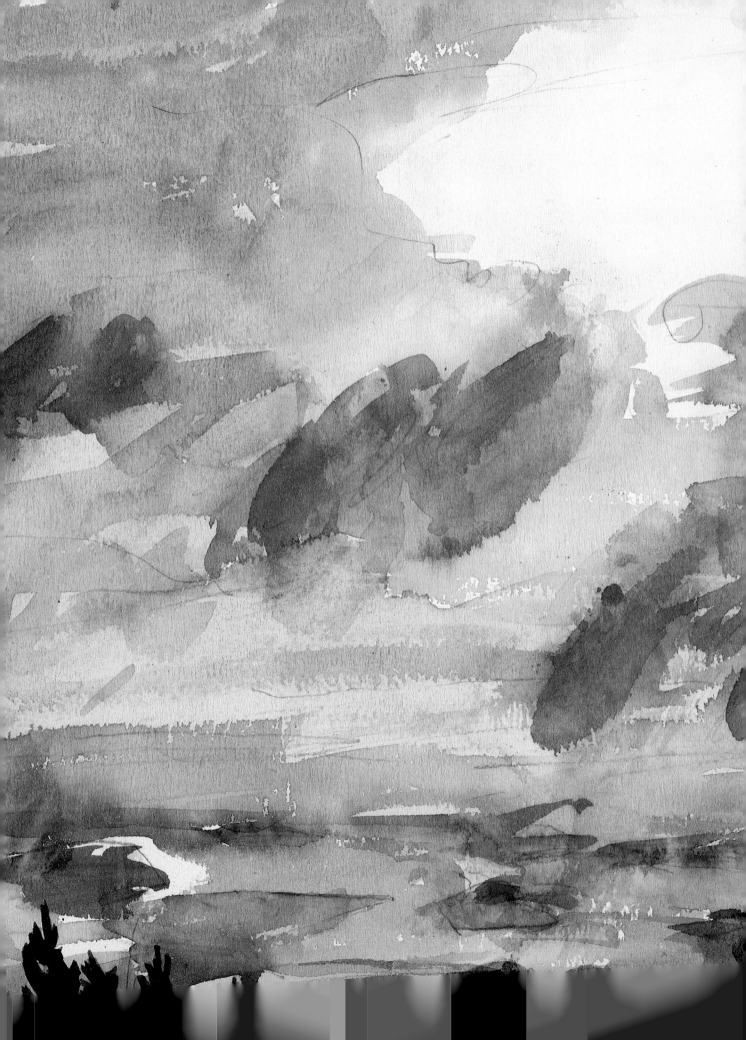

LAURENCE WOOD

WATERCOLOUR
MASTERCLASS

LEARNING FROM PROFESSIONAL ARTISTS AT WORK

ACKNOWLEDGEMENTS

I am indebted to many people for their help and inspiration in writing this book, especially to Jo-Anne for her limitless enthusiasm, and to all the artists whose co-operation and trust I gratefully acknowledge. I would also like to thank Cathy Gosling, Caroline Churton, Caroline Hill, Geraldine Christy, Glynis Edwards and all the staff at HarperCollins for their expertise, hard work and patience, and all those other people without whose help this book would not have been completed.

For my parents

First published in 1993 by
HarperCollins Publishers, London

© Laurence Wood, 1993

Laurence Wood asserts the moral right to be identified
as the author of this work.

**A CIP catalogue record for this book is available
from the British Library**

ISBN 0 00 412649 1

PAGE 1: Lesley Giles,
Rhône Glacier 1990,
305 × 510 mm (12 × 20 in)

PREVIOUS SPREAD:
Laurence Wood, *Cloud
Study II,* 305 × 455 mm
(12 × 18 in)

Editor: Geraldine Christy
Art Editor: Caroline Hill
Designer: Glynis Edwards
Photography: Ed Barber

Set in 10/13 Optima Light
by Wearset, Boldon, Tyne and Wear
Colour origination by Colourscan, Singapore
Printed and bound in Hong Kong

CONTENTS

INTRODUCTION

My first experience with a watercolour box was not a good one, so I am told. I was two and a half years old and I dismantled the box, taking out the tray containing the little blocks of paint. The recesses into which the paint blocks slotted were formed by cutting a cross in the metal and folding down the four pointed segments. The underside became a forest of razor-sharp peaks and I am glad that I cannot recall more of the incident, though I am sure that is when watercolour entered my blood!

I think I am less clumsy now, as far as watercolour is concerned, but I also know that a good watercolour demands a lot more than skill of hand. Painting is not only an act of physical dexterity. Colour, which is the most potent element in a watercolour, may be applied with the most ham-fisted technique and still convey powerful emotion. The magic of a great painting does not lie purely in the techniques displayed but in the successful amalgamation of these with a whole range of other ingredients. So, if you are trying to improve your paintings how do you discover what those ingredients are?

One method is to look closely at the paintings of artists whose work excites you. Look at the techniques they use but also look further, and try to unravel the full creative process. This is what I have tried to do in writing this book. You will find surprises as the painters featured do not always follow the neatly ordered progressive steps that you might expect. Painting a watercolour can be an event full of improvisation and spontaneous changes in direction together with tried and

trusted procedures. In trying to improve or find your own voice, learn and experiment with the vocabulary that the artists in *Watercolour Masterclass* use. Do not repeat their methods word for word, however – just absorb what will be useful to you in your own work.

A masterclass is a form of instruction normally associated with musicians. The class might start with a rendition of a piece of music and continue with a discussion and analysis of both the fundamental and the finer points of interest. In my meetings with the featured artists my role was that of a masterclass audience, to look and listen and ask questions in order to unravel their work, get behind the scenes and study what really goes into painting good watercolours.

The first two chapters perform a supporting role, discussing suitable materials and exploring the possibilities of watercolours beyond basic technique. The spirit of the book is one of great enthusiasm for the range of styles, materials and subject matter that are found in watercolour practice today. I hope that there will be something for every reader, whatever your interest in watercolour might be. I am certain that the lavish illustrations of these artists' remarkable paintings will provide a perennial source of inspiration.

'Rather than learn techniques, you can learn *how* to find them and then you are ready' (Anonymous Chinese artist).

MATERIALS

Thousands of years ago early man painted pictures with a simple mixture of powdered earth of different colours and water, thus creating the first 'water' paint. There was a major problem, however – a missing ingredient. Once this paint was dry it lost its lustre, and even worse, eventually the picture disappeared completely. No matter what surface the picture had been painted on the paint would eventually fall off or fade away. Something was needed to make the particles of pigment adhere to the painted surface, to hold them together and retain the glowing colour long after the paint had dried – a water-soluble glue that would also add a little sparkle.

A host of different materials were mixed with pigment and water to produce water paint that would last. Eggs, milk products, starches and gums were but a few that worked successfully and gave rise to paints with distinctly different appearances. However, one recipe of finely ground pigment, gum arabic and water produced a transparent, fluid and glowing paint that was simply and aptly to be named watercolour. By the mid-nineteenth century artists and their colourmen had refined this basic tripartite mixture to provide paint for the connoisseur! Numerous other ingredients were devised to create the popular watercolour we know today.

▶ *Laurence Wood,*
Storm, Torcello
300 × 395 mm (11¾ × 15½ in)
I started this painting outdoors as a huge thunderstorm was brewing. When the rain actually began to fall I was forced to seek cover in the porch of the church itself, where I was able to continue painting. I built up four or five layers of blue and blue-green washes to create the depth of colour in the sky. The white paper and touches of white gouache were used to develop the startling contrasts of light and shade. Watercolour in all its guises is for me the simplest and most expressive medium when the subject revolves around dramatic light and colour, as it does here

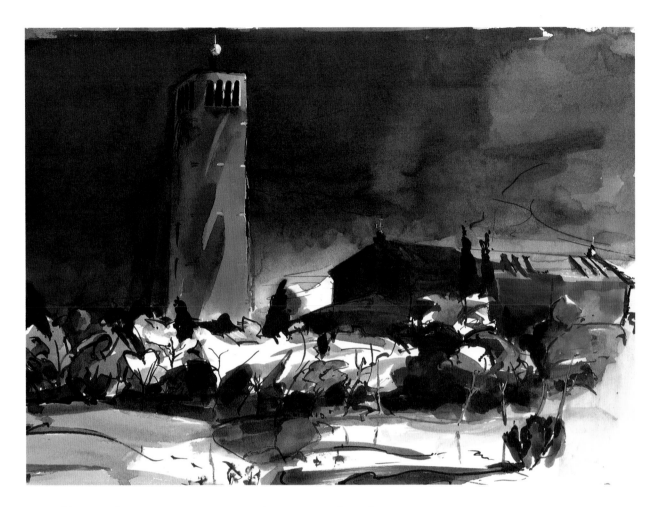

SECRET INGREDIENTS

Like most of the processed foods that we buy, watercolour contains 'additives', though you will not find them listed on the packaging. Manufacturers like to retain an element of mystery and, like the best chefs, will never disclose the 'secret ingredients' of successful paint recipes. It is only when you try to make your own watercolours that you realize what a good job the modern manufacturer does in carefully balancing the constituents of paint to make it so easy to use, so consistent and reliable. However, you must make sure that the additives in your paint are there to enhance and improve it and not to adulterate it.

The smoothness of watercolour is improved by the addition of a plasticizer such as honey or syrup; this also assists the initial grinding of the pigment into the binder (gum) and the vehicle (water). Glycerine is added to retain moisture and improve solubility. Without it cakes of watercolour would set very hard and prove difficult to redissolve. If you are the type of painter who likes to work outdoors in sub-zero conditions a drop of glycerine added to your water pot can stop it freezing and will not have any adverse effect on your painting.

Both plasticizers and glycerine improve the flow of the paint across the paper and this can be further encouraged by adding a substance to break the surface tension of the water; there is nothing worse than painting the perfect brush stroke only to watch it shrink back into an

Components of watercolour
The three basic ingredients of watercolour: gum arabic, coloured pigments and water

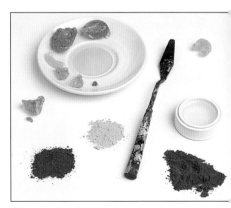

9

unintended puddle. Traditionally, ox gall was added but this has been superseded by modern chemical 'wetting' agents.

As with food there is shelf life to consider so watercolour usually contains a chemical such as formaldehyde to prevent mould growth and deterioration. Some manufacturers even add an aromatic ingredient such as clove oil to appeal to our sense of smell!

QUALITY VS. QUANTITY

Watercolour also has to appeal to our pockets and this is where quality and economy may have to reach a compromise. Pigment is the most expensive ingredient in paint and the best colours contain a high proportion of good-quality permanent pigment. It is possible to replace some of this expensive material with a cheaper, less reliable pigment but this can drastically reduce the quality of the colour and the longevity of the paint. If such an 'extender' is added to greatly increase the bulk quantity of watercolour then it can be considered an adulterant. Very cheap watercolours are likely to have been over-extended and it is false economy to buy them. The colour is weaker, they can be difficult to handle, and they make it hard to achieve the results possible with good paint. There are so many brands available today it is easy to find one that suits your budget and satisfies your aspirations. In some cases a less expensive colour might exhibit particular qualities that you like. Paul Riley, for example, prefers one particular 'student' grade Lemon Yellow to more expensive varieties because of its transparency (see page 106). He buys a mixture of cheap

and expensive paints, chosen on the grounds of specific properties that suit his flower paintings.

The most reputable watercolour manufacturers go to great lengths to study and perfect their products. Extensive research is carried out to find the most permanent and most brilliant pigments. Modern synthetic pigments and dyes have been tried and tested to produce reliable non-toxic paints that follow international quality-control standards. This is one of the advantages we have over our artistic predecessors. We do not have to spend time making our own paints; we can simply pick and choose from a vast array of good-quality watercolours. The downside to this, however, is that we cannot blame our materials when a painting is unsuccessful.

WATERCOLOUR IS NOT JUST WATERCOLOUR

A number of other types of paints use water as a vehicle and in a physical sense all are water colours.

Types of watercolour
Watercolour is available in many different forms and in different containers. Some of my own watercolour materials are shown here, including a watercolour box containing whole and half pans of solid watercolour; tubes of watercolour; and a larger tube of gouache. The coloured pastels and two coloured pencils are the water-soluble types, as are the four felt-tipped marker pens. The small bottles contain Indian ink and dye-based liquid watercolour, whereas the two bottles marked with coloured labels in the top left corner contain coloured waterproof ink that I have mixed to particular hues for outdoor sketching

However, they have developed very distinctive identities. The closest relative of transparent watercolour in terms of ingredients is gouache. Gum-based, it is made opaque by the addition of inert colourless pigment and white pigments. I often use gouache alongside watercolour paint and especially on tinted paper. *Near Folkestone* (below) was painted on dark card, using both gouache and watercolour. Some watercolour painters despise the use of any gouache or Chinese White in a watercolour painting because they prefer their colours to be totally transparent. Nevertheless, when painting on a strong tonal background the pale opaque colours of gouache create a powerful atmospheric light. Water-based colours such as distemper, casein and egg tempera are rarely used in conjunction with watercolour on paper though there is no reason why they should not be.

Laurence Wood,
Near Folkestone
370×470 mm $\left(14\frac{1}{2} \times 18\frac{1}{2}\, in\right)$
Painted at first light, I combined watercolour and gouache with brown ink. Light was streaming from a break in the cloudy sky following a rain storm. The 'misty' washes of thin gouache and the dark grey ground of the card suited the overcast, dramatic atmosphere

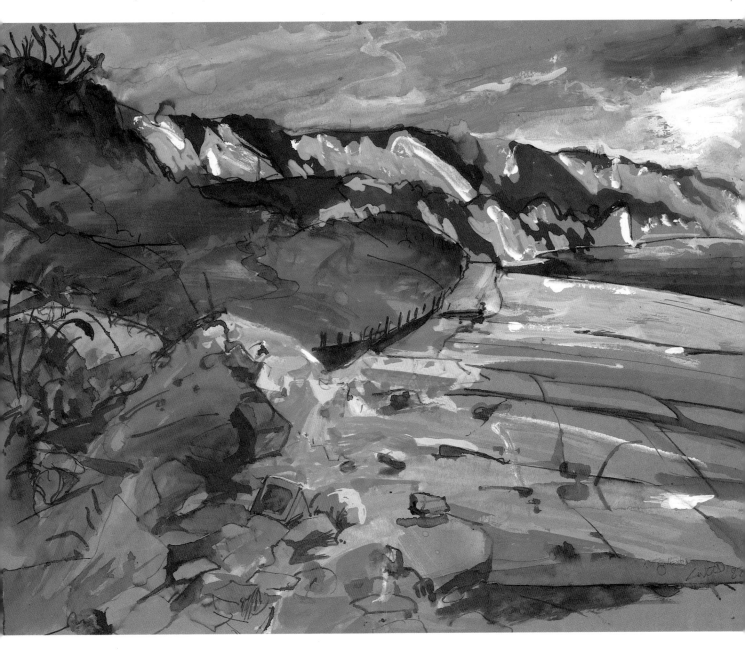

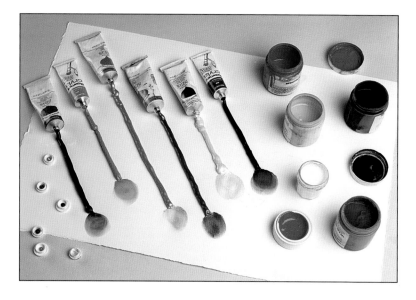

▲ Types of acrylic paint
*Acrylic paint can be bought
ready to use in tubes or pots
(either plastic or glass). The
tubes illustrated here include
pearlescent, metallic and
iridescent colours alongside
traditional hues. The pots
contain aqueous dispersions.
These are pure pigments
already suspended in water
ready to be mixed with a
synthetic resin emulsion — the
milky liquid in the small jar —
to produce 'home-made'
acrylic paint. The ceramic
saucer in the foreground
contains a mixture of emulsion
and aqueous dispersion*

▶ *Laurence Wood, Lido
610 × 840 mm (24 × 33 in)
Thin acrylic washes were
flooded across the paper and
then left to dry. After
scrubbing the painting down,
further washes of acrylic were
applied to develop the
painting, simplifying shapes
and colours and exaggerating
the perspective. My aim was
to heighten the feeling of
tension during a thunderstorm*

ACRYLIC PAINT

If, traditionally, watercolour is iden-
tified by transparent washes of pure
colour, then it has acquired another
modern relative – acrylic paint.
Acrylic paint contains similar pig-
ments but the binder is a synthetic
polymer resin. Thus a thick layer of
acrylic paint dries to a flexible plas-
tic finish. When thinned with a great
deal of water, however, acrylic
paints closely resemble conven-
tional gum-based paints. They can
be used in a similar way while wet,
but once dry are totally insoluble.
This has great appeal to some pain-
ters as it means that layers of thin
transparent colour can be built up
on the paper with no physical
intermixing between layers. The
glazing effect can produce vibrant,
glass-like colours.

Acrylic paint can be made totally
opaque by adding a colourless
'base' medium or white paint. Irides-
cent, pearlescent, fluorescent and
metallic colours are available and
can be intermixed as easily as any
other colours. Mediums other than
water can be added to increase
transparency, increase gloss or pro-
duce dead matt finishes. Acrylic

paint can also be easily combined
with watercolour. John Blockley
takes advantage of the insolubility of
acrylics when dry to create particu-
lar textures in his work (see page 64).

I use acrylic paint for work on
both paper and canvas. The painting

Lido (above) was painted in the studio using tube acrylic colours. It was based on small watercolour sketches painted outdoors during a sudden storm. There was a peculiar light quality as the sun broke through shrouds of rain, as if the whole scene had been washed out. When first dry, this painting was scrubbed under a shower in order to abrade the resilient acrylic washes and recreate the 'bleached' atmosphere originally encountered at the deserted coastal resort.

USING INK

For me ink has always formed a fascinating bridge between drawing and painting. It has the monochromatic aspect of traditional drawing media and is often used in a linear fashion, yet it can also be applied like paint as a wash. It is a traditionally favoured companion to watercolour and is often combined in the same painting. There is a long Western tradition of tinting ink drawings with watercolour, and a great Oriental tradition of ink and watercolour paintings.

I like using ink because it produces such positive brush marks and has such rich tonal potential when diluted. Indian ink, like acrylic, is waterproof when dry and can be built up in layers. The shellac it contains causes it to dry with a slight sheen, unlike any other medium.

PAPER FOR WATERCOLOURS

Paper, like paint, has evolved over many centuries and there are many different papers for different purposes. Artists seek high-quality paper for use with watercolours because the paper plays such an important role in the finished painting. It reflects light back through transparent washes, bringing the colours to life. Unlike many other paints that sit upon the surface of their support, watercolour soaks into the fabric of the paper, becoming part of it. This intimate relationship is one of the most important aspects of watercolour painting, as the artist does not simply paint *on* the paper but *with* it.

▼ *Laurence Wood,*
Blossom, Eastwood
240 × 145 mm $\left(9\frac{1}{2} × 5\frac{3}{4} in\right)$
An outdoor sketch in watercolour and sepia ink, on buff paper previously tinted with a yellow wash

▶ *Laurence Wood,*
Venetian Window
495 × 370 mm $\left(19\frac{1}{2} × 14\frac{1}{2} in\right)$
Here I combined watercolour and ink and worked boldly to convey the strength and simple grandeur of the subject. This painting has many layers of transparent colour which produce the rich, dark tones of shadow and the powerful blue of the sky. I painted with brown waterproof ink and a sable brush, conveying the contours of the arch with calligraphic brush strokes

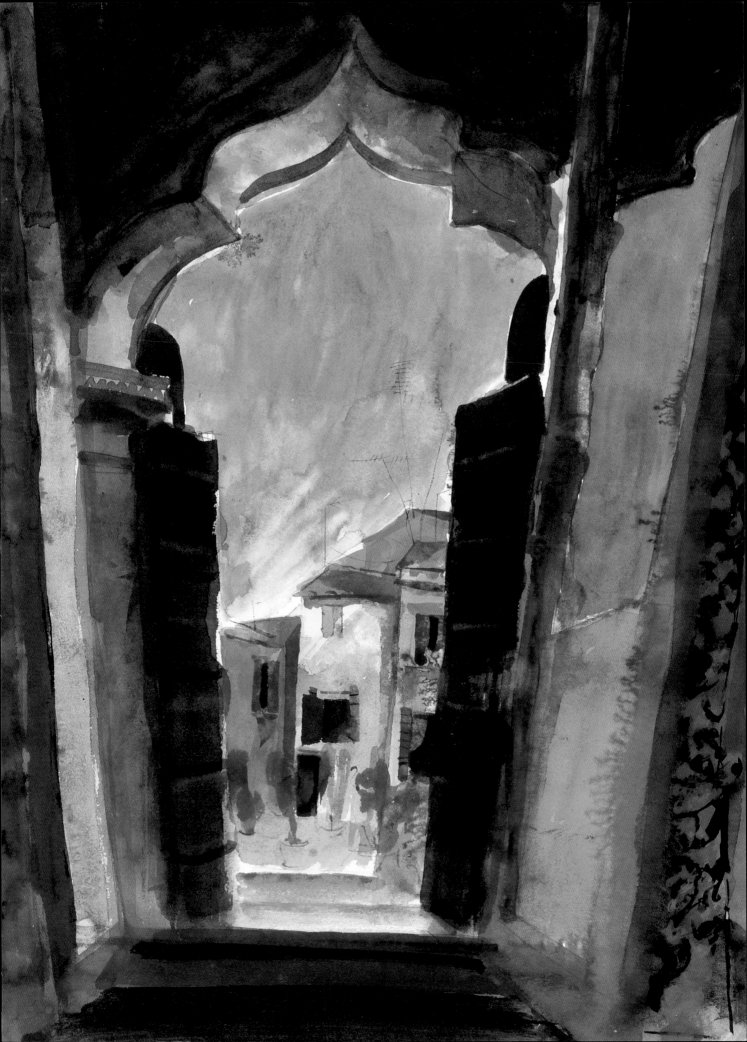

Use of white paper

An understanding of paper and its primary role in a watercolour is demonstrated clearly by these three details from Masterclass paintings. Lesley Giles leaves a large area of white paper as a prominent feature in Factory, Valetta Road *(RIGHT). John Blockley washes areas of his paintings away, as in* Flowers – White *(BELOW LEFT), skilfully manipulating the wetness and dryness of his paint, knowing just how long to leave paint in contact with the paper. He knows what will stain the paper and what will lift off to reveal its original whiteness. Charles Reid always paints on white paper. It reflects the maximum amount of light back through the thin washes, producing delicate skin tones with subtle nuances of light and colour, as seen in* Karen II *(BELOW RIGHT)*

All the artists in *Watercolour Masterclass* are particular about the paper they use because it is such an integral part of their work. Lesley Giles carefully structures her paintings around white unpainted areas of paper, and in this traditional approach the paper is literally the light in the painting, not merely a support. Paul Riley likes to use absorbent printmaking papers which 'suck' the paint from the brush, allowing him to create crisp decisive marks.

Today, as with paints, there is an excellent standard of quality control employed in making 'artist's' paper. Most papermakers, whether producing 'handmade' or 'machine-made' watercolour papers provide detailed literature on what you are buying. There are also numerous books dealing with the basics of watercolour painting that explain the different surfaces and weights available. Rare handmade paper can be extremely expensive. The famous 'Whatman' paper mentioned later by Leslie Worth is a collector's item even when it is blank!

Most medium-priced watercolour and drawing papers are very good quality. However, what you must never do is assume that expensive paper will improve your work. Using good paper does not necessarily mean you will produce a good painting; in fact, worrying too much about paper can ruin your work, making you overcautious and unwilling to experiment. As Paul Riley says on page 108: 'It's an overhead that has to be accepted or your paintings suffer.'

The most expensive Western watercolour paper is produced from pulped linen rags bleached white by the sun and it is chosen by water colour painters because of its purity and longevity. It should be free of anything that would cause it to discolour the paint chemically or by yellowing with age. It is usually 'handmade' in individual sheets and you are paying for a handcrafted product. In fact, many 'machine-made' mass-produced watercolour papers are technically just as reliable and pleasant to use, but do not have the traditional reputation of hand-crafted paper. Very cheap papers, not necessarily intended for artists' use will deteriorate, some yellowing badly after a few months, and most watercolour painters avoid them. Whatever you read about paper, and however much you spend on it, you can only evaluate it by trying it out. You should judge it using the criterion of whether or not it helps you to make good paintings.

Paper

The hue, texture and degree of absorbency of different papers affect the colour and quality of a brush stroke applied to them, as shown here. The range of paper illustrated includes, from the top, textured green and pink pastel papers; warm-white, smooth watercolour paper; bright white, lightly sized, highly absorbent printing paper; buff, rough, hand-made watercolour paper; blue-grey, medium-textured, hand-made watercolour paper; and cold-white, medium, heavily sized watercolour paper. Note how the heavy sizing creates a very 'dry' brush stroke

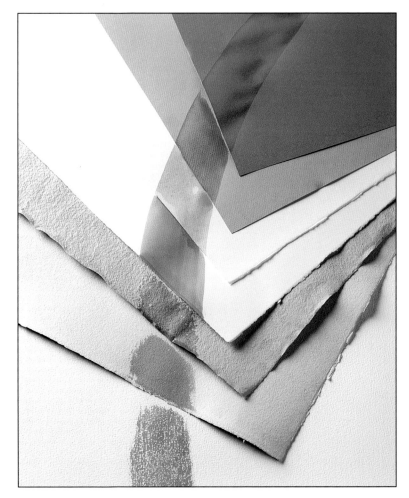

All artists have their own personal preferences for sketchbooks and blocks. Adrian Berg dislikes those sketchbooks that do not allow him to fold the front cover right underneath the backboard. I also find this, or a wire spiral binding, very distracting. I much prefer watercolour blocks, even when they start to fall apart! (I usually reinforce mine by coating the edges with PVA glue.)

There are no rules governing the preparation of watercolour paper. Lesley Giles likes to pre-stretch her paper in the traditional manner with gummed tape. John Blockley stretches his paintings when they are finished. I like the freedom of working on unstretched sheets that can be manipulated in various ways such as cutting and attaching to other sheets. You do not have to use paper just as it comes. Pure paper is highly absorbent and is commonly used as blotting paper. Japanese mulberry paper and some printmaking papers are similarly absorbent. The absorbency of a paper depends upon the amount of 'size' with which it has been impregnated. Sizing partially seals the fibres and governs the way the paint soaks into or bleeds across the paper. It is also added to protect soft-surfaced papers, helping to repel grease and dust. Some papers are so heavily sized that unless they have been soaked in water to remove some of it they will totally repel a watercolour brush stroke! I try to avoid these; the size may well have been added to increase the weight and there is little point in paying for something that you will want to remove. You can both remove size or add more if you wish; rabbit-skin glue, gelatin or PVA greatly diluted can be applied by brush or by soaking the whole sheet.

Some papers are available ready-prepared with a fine gesso-like coat-ing. These are particularly suited to ink and watercolour techniques that do not use too much water, especially watercolour marker pens. Today, very few artists bother to coat or 'dress' the surface of their paper, though many of the traditional nineteenth-century painting manuals provide recipes should you wish to experiment.

Obviously any sheet of paper can have a colour washed over the whole surface at the outset of a particular painting, but it is often useful to tint some long in advance of a painting session. Turner often did this before his painting 'tours'. If you are stretching paper simply colour the water with which you moisten it; watercolours, ink or acrylics are ideal for this. Ink or acrylics will slightly reduce the absorbency too, and will be insoluble when dry. Gouache or dilute household emulsions produce chalky tints, and fabric dyes can be used for very intense stains of colour. There has been a long-standing practice in the textile design industry of pre-tinting paper for watercolour work with diluted tea or coffee. This is applied over the preliminary pencil drawing to prevent it smudging and reduce the white glare of the paper. This results in a subtle off-white tint against which it is easier to evaluate accurate colour mixing.

BRUSHES

There are many historic photographs of famous artists at work clutching great handfuls of paintbrushes and surrounded by pots jam-packed with even more. Art shops and manufacturers promote new lines of paintbrushes every year. Do we really need this variety or are we being sold something that we could do

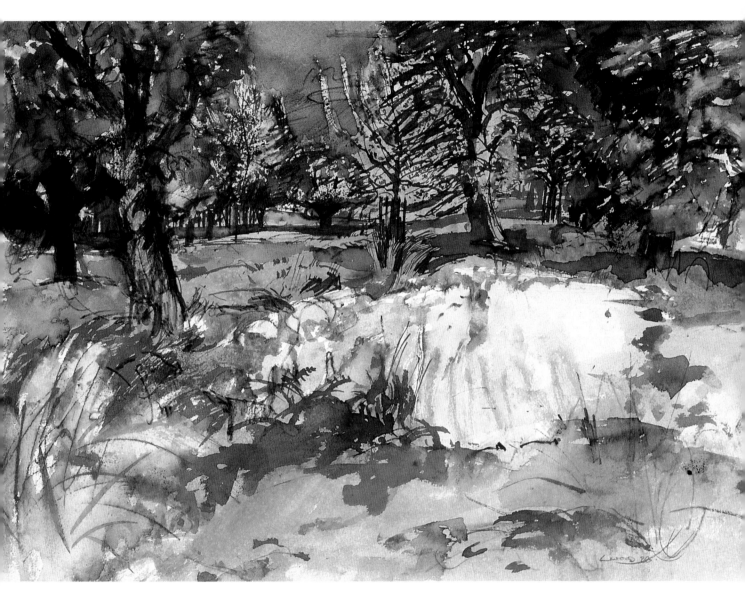

Laurence Wood,
Richmond Park
370×495 mm $\left(14\frac{1}{2} \times 19\frac{1}{2}\ in\right)$
*This outdoor painting was
made with a single quill-set
sable brush, loaded with a
mixture of orange and brown
waterproof ink. Watercolour
washes were added with the
same brush, showing the range
of marks, strokes and washes
that can easily be made with
a single brush*

without? Artists usually have strong opinions on their brushes and you will find diverse views in *Watercolour Masterclass*. It is not my intention to survey the many different brushes available or recommend any particular brand; I want to describe some of the reasons why artists choose certain brushes and what I look for in a brush. Later, in the individual masterclasses, you can see the contrasting approaches of different artists. Compare the inexpensive housepainter's brush favoured by John Blockley with the collection employed by Paul Riley.

Originally brushes were made by setting hairs into a quill, or by binding them onto a wooden shaft. They tended to be a round shape until the advent of metal ferrules that could be formed to flatten or fan the hairs or bristles. Shapes could then be made to suit particular painting techniques or to make specific marks. Different brushes evolved for different mediums. For oil painting stiffer hog-bristle brushes were used to manipulate viscous impasto paint and withstand the abrasive primed canvas support. For watercolour, brushes with soft or springy hairs

Laurence Wood,
Vaporetto, Venice
$570 \times 425 \; mm \left(22\frac{1}{2} \times 16\frac{3}{4} \; in\right)$
The fast and powerful motor
boats that ply the Venetian
canals make more of an
impression on me than the
traditional gondolas. Here the
boat is set against one of
Venice's grand dockland
buildings. The bold brushwork
in watercolour and green
and white gouache conveys
the drama and the colourful
light reflected upwards from
the water

that would hold watery paint and release it fluidly across the softer surface of paper were developed.

The most well-known and certainly the most expensive watercolour brush is the 'sable'. The hair for this brush, from the coat of the Siberian mink, or similar but less exclusive creatures, is favoured because of its natural spring and resilience when wet. It is also tapered perfectly with a fine point and a wider middle or 'belly'. This makes a brush that will hold a lot of paint and keep a fine point at the same time. By simple variation of pressure the artist can, with the same brush, produce fine lines or washes. I believe, however, that the sable brush has achieved a status well above its actual performance and in some cases is vastly overpriced.

Sable is often mixed with other less exotic hairs to make the brush stiffer or softer, or simply to reduce the cost. Ox hair or squirrel hair are the usual 'mixers', both of which also make excellent watercolour brushes in their own right. There are many other hairs in use, such as goat and badger, and names can be misleading. A 'camelhair' brush, for instance, is never made with actual camel's hair, but squirrel or something similar! Oriental brushes extend the list, with brushes called wolf, deer, rabbit and weasel.

Traditionally, the tips or points of paintbrushes were only made with natural hair or bristle, but man-made fibres are now also used. The individual strands of a good synthetic fibre brush have a man-made taper. They may also have split-ends to mimic the uneven split-end, or 'flag', of natural bristle. As with so many innovations synthetic brushes have been rejected by many traditionalists, classed as second best or only suitable for non-artistic use. My

advice is to try them out for yourself as some of them are very good.

Whatever the origin of the hair or the brush the only test is to paint with it and see if it suits the way you work. Your paintbrush translates your intentions and hand movements into a visible mark, a brush stroke. Just because a brush was designed to be used in a certain way or with a particular medium does not mean that it is limited to that purpose. My own brush collection for watercolour work can be seen opposite. I often use large oil-painting bristle brushes too. I enjoy the very different range of marks that can be made with a number of brushes, though one or two usually get more use than others because of their versatility, such as the small quill-set sable.

I dislike brushes that are too soft and always check for this when buying them. I pick up some water with the brush and then press and draw it firmly across a flat surface. The heel where the hairs bend in contact with the paper should not be too close to the ferrule and the latter must not touch the paper. Ideally there should be a slight springiness even in a soft brush. However, you cannot always tell what will eventually turn out to be a good brush; Cherryl Fountain finds that she has to do hours and hours of painting with a brush before it is 'worn' in and she is familiar with its character.

There are certain qualities that I look for in different shaped brushes too. A good round brush must come to a fine point when wet. Flat or chisel-shaped brushes should not splay out excessively when gentle pressure is applied. There should never be loose hairs, and a good length of hair must be enclosed in the ferrule to make sure the hairs will not fall out after a few sessions. The ferrule must be solidly fitted onto the

handle; probably one of the most common faults of poor-quality brushes is a loose-fitting ferrule.

Handle shapes and lengths have evolved through centuries of use by artists to suit different mediums and associated techniques. Long handles have traditionally been used for oil painting. The brush had to span a long distance between the hand and the wet paint, especially if the artist employed a mahlstick. Short-handled brushes tended to be favoured by the watercolour painter working on paper with much quicker drying paint. The handle also balances the point and makes it easier to control if it is ergonomically suited to your hand. I find that I have to modify some small brushes with a few wraps of masking tape, to make them easier to hold. Handles fulfil a decorative role, too, but this is probably of more importance to the manufacturer than the artist. It is best to concentrate on the business end when buying brushes and not be seduced by a stylish handle.

You have to think of paintbrushes, like paint and paper, as consumable materials. They will wear out if you use them. I, like many artists, enjoy wearing out brushes, exploiting their changes in behaviour. Feel free to modify your brushes to suit their function, like Kim Atkinson (see page 37); if you prefer a shorter handle, for example, then just cut it down! One historic painting manual describes how a large sable brush can be tailored to produce a particular brush stroke. The brush, having been dipped into linseed oil, is left to dry for six months. It is then treated with solvent to remove the dry oil from the outer layers of hairs, but leaving behind a hardened core. Could you be that ruthless with your new large sable in pursuit of the perfect brush stroke?

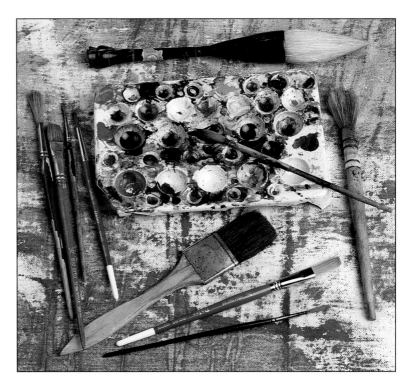

OTHER EQUIPMENT

Art shops stock a vast range of other equipment for the watercolour artist, including easels, boards, folding-chairs, umbrellas, bags, boxes and palettes. Some can be very useful and some are completely unnecessary. It is for you as an individual to decide what you need to help you paint a watercolour indoors or outdoors. Easels and chairs have to be tried out in person to see if they suit you and your budget. It is important to strike a balance between comfort, function and expenditure. I and many artists improvise for most equipment other than paint, paper and brushes. I rarely buy art-shop palettes, for example, though some are superb. Watercolour can be mixed on any non-absorbent surface and I simply take advantage of the diversity of modern food packaging. Just think of the quantity of plastic cartons, containers, bottles and trays that we throw away; many are ideal for paint mixing and storing.

Watercolour brushes and palette
Of these ten watercolour brushes I use two or three frequently and the others just occasionally to make particular marks. The quill-set sable on the ceramic palette, the large flat brush below it, and the small, long-haired sable at the bottom of the picture are the real work horses of the group. The large Chinese brush at the top is used less often, but it can hold an enormous amount of colour and can be controlled to produce long, continuous strokes and generous blotches of paint

EXPLORING WATERCOLOUR

M any artists devote hours and hours of practice in pursuit of acquiring perfect technique. This is only a means to an end, however, and their real quest is to learn how to make good paintings. They must also experiment and learn how to apply their hard-won dexterity for, unlike the musician, the painter plays the role of both composer and performer.

By improvising you learn and acquire ways of painting that are spontaneous and innovative, and can take advantage of discoveries as you paint. Even mistakes or accidents can be transformed into new ways of painting your subject, new extensions to your creative repertoire.

The painter explores a subject or theme and the medium of paint itself at the same time, and each artist does so differently. I could give all the artists featured in *Watercolour Masterclass* two or three colours, the same-sized brush, restrict them to a basic technique such as 'graded washes', then ask them to paint the same apple and they would all paint something totally different and original. This is why we admire them, not simply for their dexterity but for their powers of innovation, the surprises that they point out in a visual world that we can so lazily take for granted.

► *Laurence Wood, Dark Trees, Light and Rain, Italy*
370 × 495 mm ($14\frac{1}{2} × 19\frac{1}{2}$ in)
Letting the paint do the work would be a good description of how I tackled this rapid outdoor painting. I was actually working on another, more detailed, architectural subject when a rain storm temporarily intervened. The combination of yellow sunlight and veils of fine rain produced surprising and beautiful effects. I painted as quickly and spontaneously as I could, allowing the colours to run and mix on the paper, concentrating on capturing the essence of a transitory spectacle

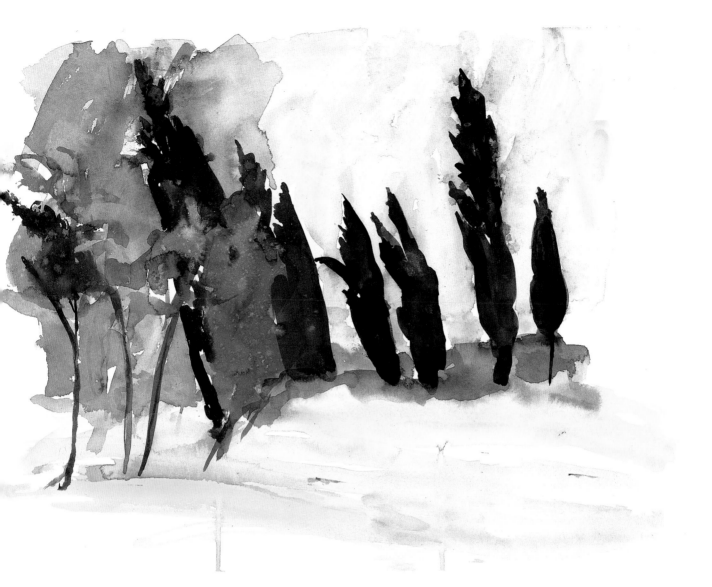

TRIAL AND ERROR

During my conversations with the artists featured, one particular point was often raised. Despite, in most cases, years of art school training not one artist was really taught to paint with watercolour. The accomplished paintings they now create with it are the result of personal experiment, years of trial and error fuelled by sheer enjoyment. As a result the artists do not lay down any 'rules'; what they have picked up from peers, books and tutors is viewed as a starting point, a springboard for their own individual explorations. I share the view that, although there are technical conventions, there are in fact no technical rules in watercolour painting, only technical possibilities.

PAINT CONTROL

For some artists, perhaps familiar with a medium such as oil paint, learning to control fluid watercolour can be a difficult task. Watercolour is not easy to correct without losing the benefits of spontaneity, simplicity and freshness. The marks that you make, the brush strokes or

Brush marks

The detail of Charles Reid's Girl in Black *(*BELOW LEFT*) exhibits an array of fine lines, wet dribbles, dry-brush techniques and scratched-out squiggles. Paul Riley who, like Charles Reid, particularly enjoys brushes and brush strokes, also fills his watercolours with energetic marks. This detail from* Yellow Roses *(*BOTTOM LEFT*) shows a pattern of different-shaped brush strokes laid down in multiple directions. They record his dynamic response to the subject and to the medium itself. Cherryl Fountain employed a small brush and a lot of patience to paint the*

squirrel's fur in All Things Bright *(*BELOW RIGHT*), carefully following the contours of the underlying forms. The intricate pattern of fine marks contrasts with the flat washes of the smooth plant pots immediately behind. The detail of* Hills, Autumn *(*BOTTOM RIGHT*) by John Blockley shows his distinctive touch, controlling washed-out areas of paint, broad sweeps of watery paint, wet-into-wet washes and layers of strong colour*

washes, have to be in the right place first time. How will you ever cope with this watery paint that seems to have a life of its own?

The answer to this question is to explore and exploit the fluidity of watercolour for all it is worth. John Blockley uses water itself as a painting 'tool'. You have to work with the nature of the medium and not against it. Initially it makes sense just to try applying watercolour to paper with a whole range of brushes, sponges and other implements to see what kind of marks are possible. There are many books from which you can also learn the basic techniques such as dry-brush, flat or graded washes.

Beyond learning and practising techniques you learn by trial and error in individual paintings how to

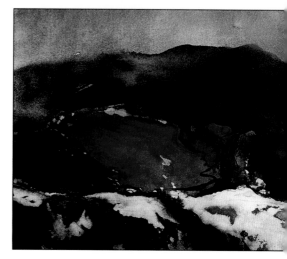

manipulate the paint and be constantly alert to new possibilities. The marks, textures and aqueous properties of watercolour that I exploit in my paintings and drawings are illustrated in this and the previous chapter. Later in the masterclasses you can study in detail how other artists manipulate the medium.

Although I have experimented with sponges, feathers, reeds and pads of felt I rarely paint with anything other than a paintbrush and a wet, crumpled paper tissue. The only other method that I regularly use to apply paint is simply to pour it onto the paper to flood areas with an overall colour. I have always enjoyed the combination of lines and washes that can be made simply with a brush. In general, I have always preferred drawing with brush and ink rather than with pencil or charcoal.

The marks made with a brush can be fine and fragile or bold and sweeping according to the slightest alteration of pressure or change in angle of attack. Brushed lines also express more movement and rhythm, carrying the eye around the paper at different paces.

EXPRESSIVE COLOUR

Colour is such an important part of our day-to-day life. We are fastidious in our choice of what colours to wear or to decorate our homes with, harbouring strong personal preferences. When painting with watercolour these same preferences tend to filter through in the colours we mix and the combinations we paint onto the paper. Even when we are mixing the 'local' colours of a subject before us we are being selective, employing 'artistic licence' right from the outset.

Colour to create mood
These two details provide contrasting examples of mood and atmosphere created primarily by colour, and every viewer may well respond to each painting differently. For me the intense orange, crimson and deep violet hues in Lesley Giles's Back Alley *create an aura of tension* (ABOVE). *The juxtaposition of colours is harsh and yet simultaneously conjures up the calm feelings I associate with sunsets. The cooler, greyer palette of Adrian Berg's* Pinetum, Nymans, 18 October 1988 *conveys the freshness of a rainy day tinged with a mood of lyrical melancholy* (LEFT)

When you sit down to paint a sunny landscape do you tend to concentrate on mixing the bright colours of sunlit forms or are you drawn towards the darkness of the shadows? Our personality or our mood is carried into the painting by colours which we might describe with words such as delicate, robust, harmonious, disturbing, for example. In the details of masterclass paintings above you can see how even a portion of a painting creates a particular colour mood.

To learn to paint expressively with colour requires personal experiment, literally playing with colours to see what you can do with them. You have to do this with great freedom, pushing paint, colour and of course yourself to the limit! In his masterclass John Blockley describes how he sometimes starts a painting just with colour: 'Every so often I think back to a colour that I couldn't get on with and I just start with it, trying not to play safe.' This is the spirit that you must foster.

On one occasion when I was out painting in the landscape I became fascinated with the colours of the lichens growing on the trees and rocks. I decided to see what happened if I powdered them up and mixed them with a little PVA glue. I then experimented likewise with the dry spores from a puff-ball toadstool. The resulting sheet of explorations was a much better account of that particular day's painting than the landscape I started out with, which ended up in the bin!

Laurence Wood, Lichens and Toadstools
265 × 305 mm (10½ × 12 in)
What started out as a sheet of black ink drawings on smooth white cartridge paper became a playful collection of experiments that incorporated watercolour, PVA glue, flower petals, lichens and spores!

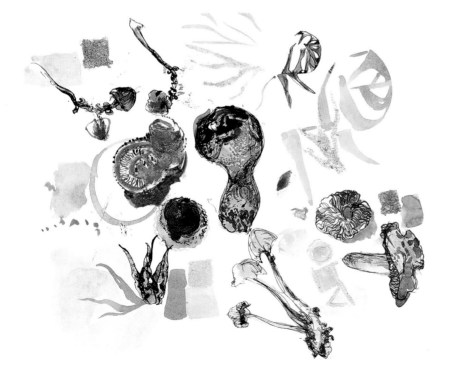

COLOURED GROUNDS

Paper and its colour are integral parts of any watercolour painting's final appearance, because of the transparency of the medium. A coloured paper will also affect opaque colours that are painted on to it. As an experiment, try painting some swatches of pale green gouache onto red or terracotta paper. Then paint the same pale green onto yellow paper and look at the difference – it is difficult to believe that the same colour has been put down. Colour theory is a huge subject and it is worth reading about in detail to supplement your own discoveries, but my own interest here is to encourage you to experiment with coloured paper as part of your general colour explorations.

Coloured paper includes not only bright colours but the varying degrees of white such as 'cold bluish' white and 'warm yellowish' white. As mentioned in Chapter 1, you can create a range of subtle nuances by tinting your own paper. Kim Atkinson describes how she enjoys the rich 'unbleached' colour of some sugar paper, while Lesley Giles paints on very bright white paper so that as much light as possible is reflected back through the multiple layers of colour. You will find that some techniques, such as wax resist, suddenly open up vast new colour possibilities when employed on coloured paper.

Occasionally I make up my own watercolour blocks with a mixture of papers in each. When out sketching with one of these I am never sure what is coming next after the top leaf has been painted on. I especially like painting on buff paper. *Factory Interior, British Sidac* (opposite) was painted on a grey-buff watercolour paper, making use of transparent

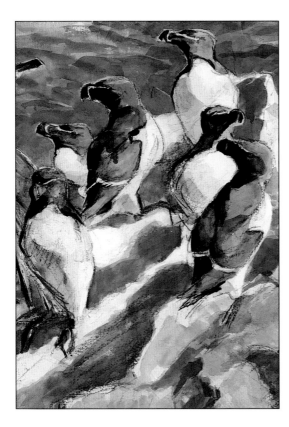

◄ *Kim Atkinson*, Razorbills and Shags (detail)
This painting was done on a buff-coloured Indian handmade paper. The tone of the paper functions as a mid tone for the whole painting. Dark watercolour washes are added on the forms of the birds for deeper shadow tones, and white gouache to indicate the strongest light. The trio of tones create a strong sculptural quality. This particular paper also has a slight tooth, ideally suited to Kim's use of charcoal or chalk, adding a slight granular texture to areas of the painting

▼ *Laurence Wood*, Factory Interior, British Sidac
560 × 760 mm (22 × 30 in)
The interior of this delapidated factory was full of unusual shapes and colour combinations, such as the pale green painted walls and the crimson red ducting and large box. I started off with a bold linear brush sketch, using a mixture of Prussian Blue, Payne's Grey and Vandyke Brown watercolour. This was followed by washes of watercolour and diluted Chinese White applied over wet colours already on the paper. I wanted to re-create the complex cluttered space, the colours of old peeling paint, the dark empty door-ways and the puddled floor

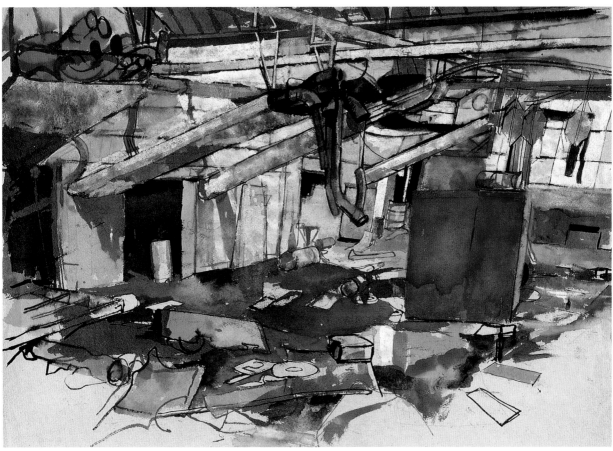

colours and translucent scumbled washes with Chinese White added to them.

Do not confine your experiments to the secrecy of a sketchbook. I find it exciting to take a full sheet of paper on which I can try out ideas side by side. These paintings are then pinned up around the studio walls from where they will fuel ideas and suggest possibilities for long periods of time.

LEARNING FROM THE SUBJECT

Painting pure colours side by side to learn about the way that they affect each other is essential practice, and it is also important to paint with the same sense of experiment and freedom in response to one of your subjects. If you paint figures, for example, you might explore different ways of mixing skin and hair colours. This will take you into the realms of juxtaposing subtle balances between translucency and opacity that you can see in the detail from Charles Reid's *Karen II* (opposite).

I revel in painting the sudden colour changes of the sky. If you are not a landscape painter, tackling an expanse of cloud-strewn sky is well worth doing just as an exploration of colour and fluid paint. It is a constantly changing subject that will force you to react spontaneously and imaginatively. Transitions of colour can be almost imperceptible or strikingly different. As with skin tones you have to modulate the degree of transparency of the colours skilfully to create the right luminosity. You also have to create a virtually intangible sense of space. Paul Riley describes how for him flowers provide 'fluid shapes and colour rich with abstract potential', a subject he can paint with great freedom.

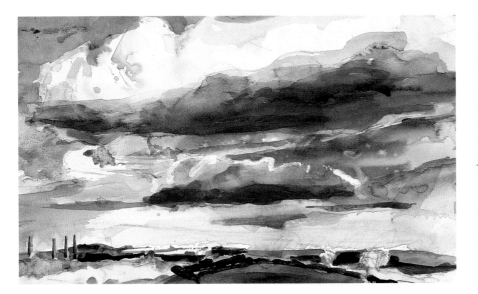

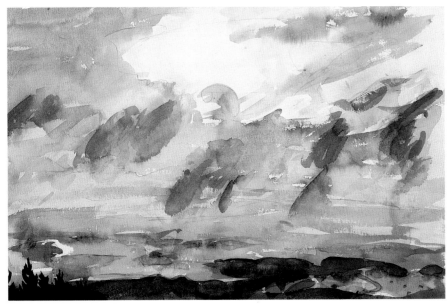

◀ *Laurence Wood, Cloud Study I and II*
225 × 405 mm (9 × 16 in)
305 × 455 mm (12 × 18 in)
You have to paint rapidly and confidently when trying to capture the fleeting changes of light, colour and shape that fill a cloudy sky. In Cloud Study I (TOP) I added some Chinese White, applying the paint from the nozzle of the tube to outline the lower cloud and contrast with the dark broad-shadowed underside of the larger, closer one. There is an amazing range of colour to be discovered in a sky like this, which will also dominate the colours of the land over which the massive clouds hover. In Cloud Study II (BOTTOM) a procession of small grey clouds were streaming across the panoramic view, low to the horizon and in front of a large patch of bright light. The whole sky was filled with layers of grey and yellow clouds and mist, overlapping like layers of coloured wet tissue paper fading into a blue-green distant haze

◀ *Laurence Wood, Grey Clouds*
560 × 225 mm (22 × 9 in)
This rapid thirty-minute painting was made using pencil and watercolour. Huge grey clouds and a pale oval of Lemon Yellow light dominate this landscape. Pale grey washes were painted first to block in the clouds, and while these dried I worked up the autumnal colours of the land and tree. Then I returned to the sky, putting down just one more wash of darker grey with a large brush to keep the light, airy, windy atmosphere

▶ *Charles Reid, Karen II (detail)*
Here you can see the manipulation of not only tone and colour but also paint density. The hair is painted with opaque earth, and yellow colours, whilst the pale glow of the sitter's face is created with washes of very dilute, more transparent colours

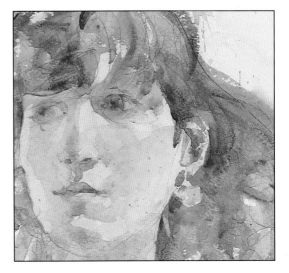

29

I respond to skies with the same enthusiasm, finding them the perfect springboard for exploring colour in its own right.

LOCAL COLOURS

If painting the sky is like trying to capture the intangible and the elusive, then a good antidote is to come down to earth and find some rusting metal! However experienced you are with watercolour it is essential constantly to feed your creative mind with food for thought. It is very useful to explore different palettes, different families of colour, to avoid getting bored or becoming too predictable. Find an object or a part of an object that is rich in colour and texture, scrutinize it and handle it, and then paint it in the most tactile way that you can. In my painting of a rusting industrial artefact (I do not actually know what it was) I built up layers of orange and red, brown and violet to try to recreate the surprisingly intense colours. The rust had a smooth velvety texture, not at all metallic. In fact, everything about this subject was surprising. The almost ugly shape adorned with rich warm colours was a pleasure to paint. At the edge of the sheet you can see the full gamut of colours that I had to explore to get it right.

Many non-figurative artists study the colours of their own environment as a source of inspiration. It can be refreshing to look very closely at the 'local' colours of your surroundings and use colour instinctively from your imagination. Learning about colour beyond the basics of colour mixing requires a personal programme of research and development. Try things out and let your paintings develop naturally, let them change. John Blockley has found that his 'black and inky mountains' have over years of experiment become 'paler, more vaporous and more delicate'.

INK AND WATERCOLOUR

I like to combine ink, usually brown or black, and watercolour in the same painting. When ink is mixed with watercolour the result can be unpredictable and exciting; sediment sometimes forms, thus producing a granular wash. This can be manipulated to create textures as in *Venetian Window* on page 15 where I mixed brown and black waterproof ink with watercolour. The ink was blotted frequently to lift off portions of it and create a surface that is pitted and 'weathered' like the original subject.

I also draw with ink, in preparation for pure watercolour work. *Storm Damage* (opposite) was painted the morning after terrible winds devastated the famous woodlands and wooded gardens of southern England in 1987. It is one of a number of drawings made over a

Laurence Wood, Rust
430 × 545 mm (17 × 21½ in)
This watercolour study of a rusted metal object was built up in a series of layers of transparent colour to achieve a rich, intense orange brown. A few final touches of pale pink gouache were added to describe vestiges of paint that remained. I dabbed the wet watercolour with a tissue to add subtle variety to the washes and create soft texture and light

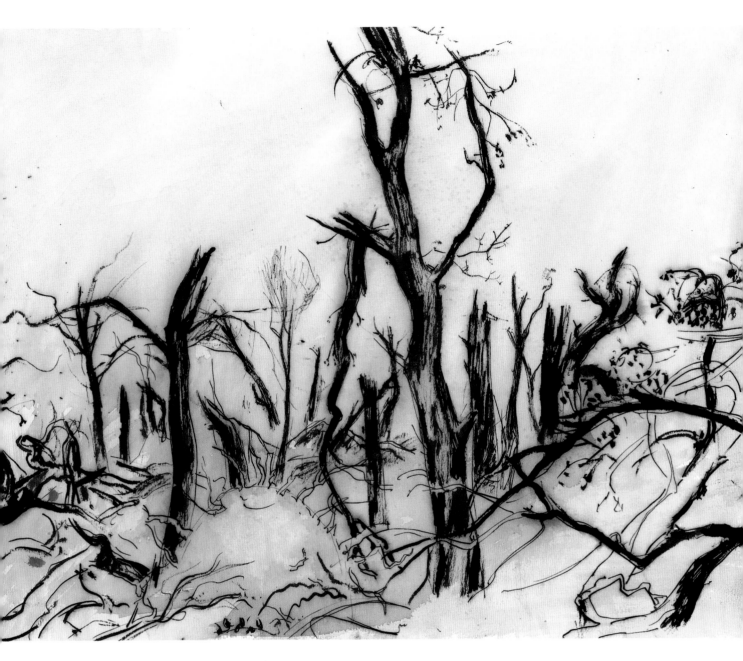

period of a few days working with a dip-pen, one sable brush and a mixture of orange, brown and black waterproof ink. As I worked a very fine drizzle settled on the paper, causing some of the ink to bleed out from the damp brush strokes. It seemed to suit the atmosphere of the cold wet day perfectly.

Back at the studio when the paper was dry I outlined some of the tree forms with a fine pen line. When this had dried I poured a very dilute

Laurence Wood,
Storm Damage
455 × 510 mm (18 × 20 in)
This painting was made with a mixture of orange, brown and black waterproof ink on white watercolour paper. It is one of a series of images made in preparation for Storm Damage, Emmett's

Laurence Wood, Storm Damage, Emmett's

560 × 760 mm (22 × 30 in)
This watercolour was painted on pale orange tinted paper. The garden was an impassable tangle of fallen trees, many split to reveal orange wood beneath greenish bark. The scene had an elegance akin to a classical ruin. This version exploits that quality whereas the sketches, are closer to the more chaotic state that initially confronted me (Reproduced courtesy of the National Trust Foundation for Art)

wash of grey-green watercolour across the top of the drawing and let it spread downwards at random over the drawing with the aid of a tissue soaked in the same watery paint.

Storm Damage, Emmett's is the watercolour that grew out of the sequence of inky preliminaries. It is painted on a sheet of paper initially tinted with very pale orange watercolour. I started with an energetic brush drawing, using a slightly stronger, more brown colour. I let the paint run around and dribble, concentrating on creating a sense of movement within the sea of tangled branches. When this initial underpainting was dry I built up the

washes gradually, strengthening the image in places but leaving delicate fragments of the initial underpainting to show through. Pale violet blue was swept over the sky with wet tissue, and finally, with a dry brush technique, I developed the texture of the green-brown trees. The painting was done in the studio by working from the outdoor ink drawings and my imagination. I also had a large fallen branch in the studio covered in moss and lichens from which I could glean colour ideas.

Hawthorn is a recent experiment with ink, watercolour, and viewpoint. It consists of four pieces of paper taped together on the reverse

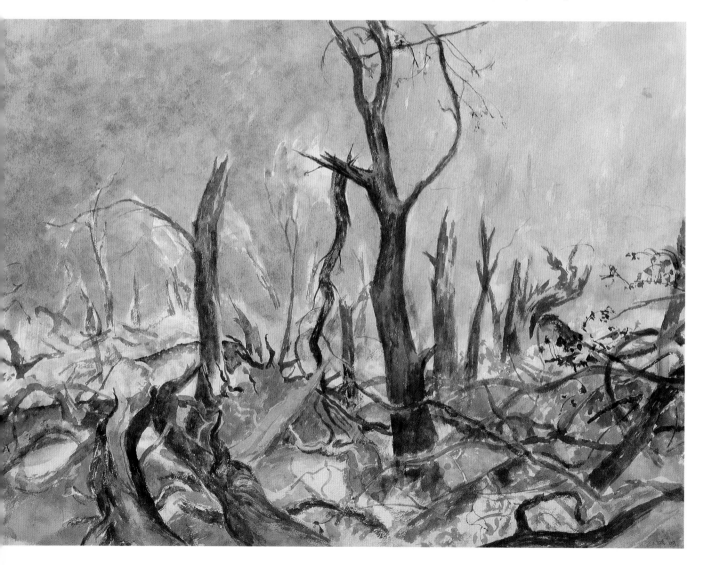

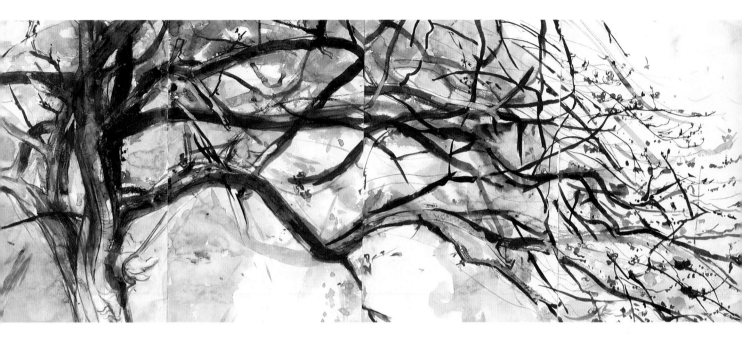

side. I painted each panel individually, standing in front of the same hawthorn tree but looking from slightly different viewpoints and from different distances, combining black watercolour-pencil with brown and black ink. After joining the panels together, and still working outdoors, I worked over the ink painting with watercolour and a range of different brushes to create a variety of marks for leaves and berries.

DEVELOPING INSTINCT

It is not easy to paint successful watercolours. I wish that I could say that it becomes easier with experience. True, you gain in confidence as you refine your skills and you think less about 'handling' the paint because it begins to feel more natural to you, but you tend to become hypercritical of your painting and you also think more about interpreting your subject, which can be more difficult than the paint itself. In my discussions with Leslie Worth he said that you need to have enough technique to be able to forget all

about it. That way, you can concentrate on what you are painting.

I think that once you are familiar with a wide range of watercolour techniques, even some of those nuggets of wisdom that you respond to in *Watercolour Masterclass*, you will find that there are many you do not need! Rather like cooking on a campfire you have to be selective as well as simple and creative. Mastery resides in an ability to make the ordinary wonderful.

I hope that this account of my own passion for watercolour and the accumulated wisdom of the following masterclasses helps you to paint better watercolours. Above all else I hope that you will also experience the sheer pleasure that I have found viewing the remarkable paintings of these accomplished artists.

Laurence Wood, Hawthorn
355 × 810 mm (14 × 32 in)
I have never really enjoyed working in sketchbooks because I often want to carry on painting beyond the edges in one direction or another. Adding on sheets so that I could do this led me into exploring the idea of assembling a sequence of images of a tree painted from different distances as I approached or walked around it. This is just one of a series of ongoing experiments with different formats and ways of interpreting subjects

MASTERCLASS
with Kim Atkinson

Kim Atkinson has a long-standing passion for painting and drawing outdoors. Brought up on Bardsey Island off the coast of North Wales she has fond memories of special days out sketching with her mother. Later, at art school on the Cornish coast, she drew and painted landscapes and plants. It is ironic that when she moved from the seaside to the city, as a student at the Royal College of Art in London, she began to develop another passion for drawing and painting birds from life. Many years later this is still her favourite challenge, especially when the subject is a wild bird in its natural environment. Kim now lives on Bardsey again and is out and about most days with some form of sketching material, 'not always colours, but always a pencil and paper'.

For Kim it is a bird's characteristics and expression, and its place in nature, that are of interest. The often dramatic background elements of light, weather and landscape are as important in her watercolours as the birds. Recently she has been sketching and painting birds in groups, trying to express their relationship to the environment. In *Razorbills and Shags* (overleaf), for example, she has focused on the birds as sculptural forms closely integrated with the rock forms that they inhabit.

▶ Herring Gulls
in Nesting Colony
610 × 425 mm (24 × 16¾ in)
Kim observed this lively colony of adult and juvenile gulls through binoculars and with the naked eye. With a combination of bold charcoal lines and watercolour, this is a typical example of Kim's energetic style. The high viewpoint enables her to transform the sea and sunlit rocks into a colourful background for the more monochromatic birds

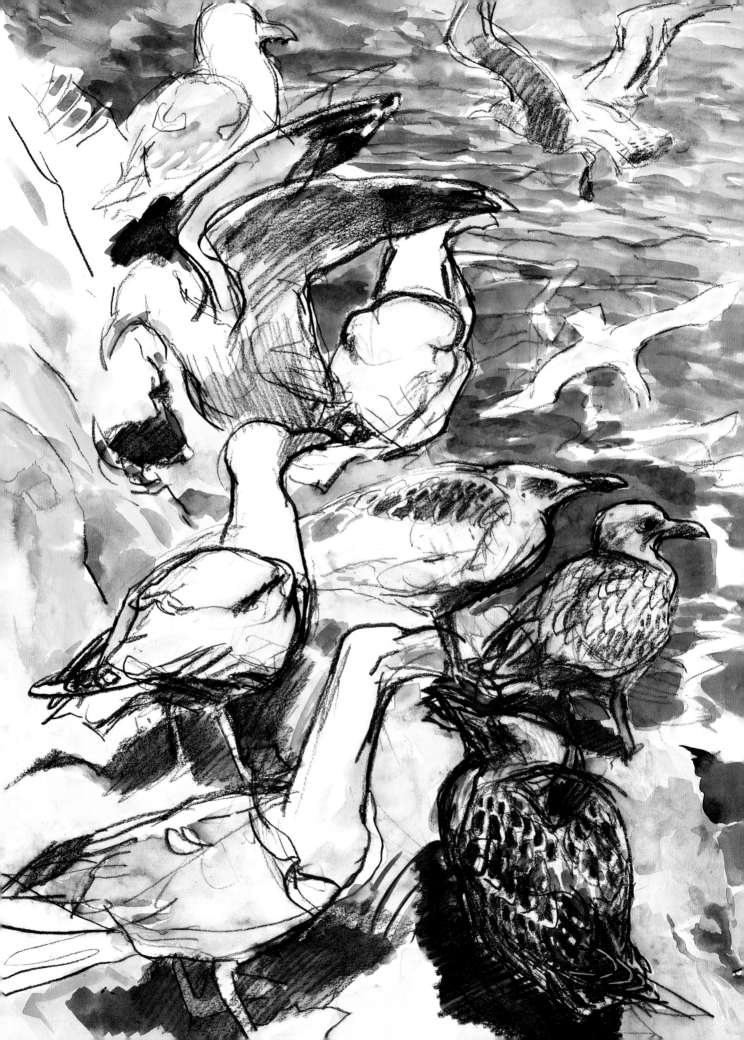

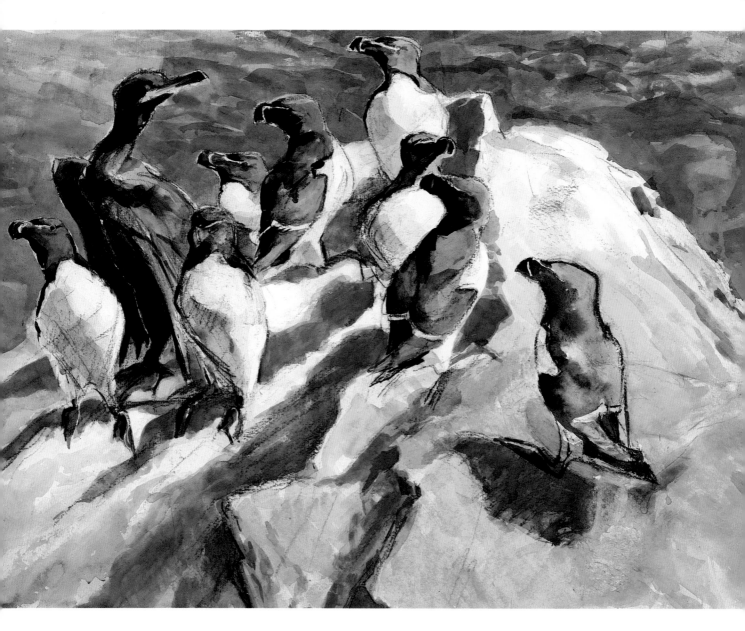

Razorbills and Shags
545 × 760 mm (21½ × 30 in)
Kim has capitalized on strong
contrasts of light and shade to
emphasize the sculptural form
of the birds. The painting is
done in charcoal and
watercolour on a
buff-coloured handmade
Indian paper. Chinese White
brush strokes highlight the
forms of the birds so that they
stand out dramatically
against the slightly darker
tone of the paper

DRAWING AND PAINTING MATERIALS

Kim draws with a wide range of materials, including soluble felt-tipped pens, watercolour pencils, graphite, compressed charcoal and china-marking pencils. She soaks charcoal in linseed oil to make it intensely black and water repellent, and she also combines wax crayons with watercolour.

For painting she uses both large and small oil-painter's bristle brushes and sable-mixture flat watercolour

brushes. Due to the large scale of some of her paintings, and the great number that she paints, Kim gets through large quantities of paint and Indian ink. Sometimes when working on very large paintings she substitutes household white emulsion paint for white gouache; she likes the visual contrast that opaque chalky areas make against transparent, luminous passages.

When painting outdoors Kim carries an old paintbox that once belonged to her grandfather, squeezing fresh tube watercolour into empty

pans to replenish them. The pan of pale turquoise green, however, came with the original box and is possibly over fifty years old: 'I am not so keen on green and usually play it down with Yellow Ochre.' On occasion, however, this turquoise is ideal, as can be seen on the fulmar's beak on page 43. Green is probably the only colour that Kim uses sparingly.

She tends to stick with tried and trusted favourites when buying paints; these include Ultramarine Blue, Raw Sienna and Yellow Ochre. Her working palette relates closely to the local colour of her location. Kim painted for a time in Australia and started to use vivid colours such as orange and bright blue, but she has little use for these on Bardsey Island.

PAPER

Kim dislikes using sketchbooks as she finds that a drawing may often be spoiled by rubbing against another, preferring to take a few sheets of paper out with her as 'the day's quota'. These sheets of paper might well be fragments of larger sheets of different types carried in a small cardboard folder or clipped to a piece of hardboard. Separate sheets provide her with more choice of suitable supports for her work. The sketches of *Redwing* (right) were made with pencil and watercolour on a folded fragment of thin cartridge paper.

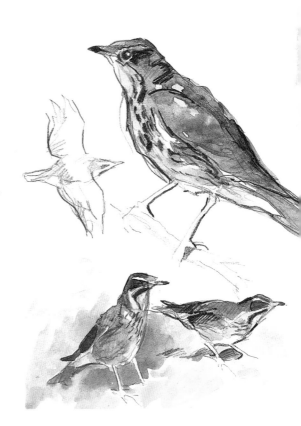

▲ Painting equipment
Kim's paintbox also contains a pencil, an eraser, a paper tissue, compressed charcoal and two paintbrushes. She replenishes her paintbox with squeezed-out tube colours that are then left to dry in the pans. Notice that Kim has broken off the handle of the paintbrush so that it will fit into the box!

▶ Redwing
210×145 mm $\left(8\frac{1}{4} \times 5\frac{3}{4} in\right)$
Kim produced this small pencil and watercolour sketch on a folded piece of cartridge. The redwing was observed through 10×40 binoculars. These do not show the magnified detail of a telescope, but are lighter to carry around. When drawing Kim holds the binoculars still as she studies her subject, and tries to move her eyes around rather than her head

▶ Cormorants

995 × 1120 mm (39¼ × 44 in)
This large-scale watercolour
exploits charcoal, black chalk
and white emulsion paint. The
birds have carefully rendered
silhouettes and stand out like
bronze sculptures against the
more delicate waves behind
them. The high horizon line
evokes the impression of great
distance. Kim sensitively
breaks the line that describes
the throat of the standing bird
on the right, thereby creating
a touch of light

▼ Herring Gulls and
Great Black-backed Gulls

305 × 855 mm (12 × 33¼ in)
There is a lively sense of
movement in this watercolour
and a delightful contrast
between the strong compressed
charcoal lines and the
wet-into-wet washes of colour.
The shapes of the birds carry
the viewer's eye along the
narrow composition as if they
are changing place constantly.
Kim chose this shape of paper
to heighten the sense of
activity as the gulls take their
positions facing into the wind

Although sugar paper is not ideal from the point of view of durability and conservation, Kim finds it an excellent surface to work on with charcoal and watercolour. She particularly likes cream or buff sugar paper or other papers with a similar 'unbleached' appearance and good tooth. Sometimes she exploits the warm subtle colour of black tea to tint a sheet of paper.

In the main Kim prefers good-quality lightweight watercolour or cartridge paper, printmaking paper and Asian handmade papers. Not only does she enjoy working on a variety of types of paper but she also likes a selection of sizes. On-the-spot sketches such as *Redwing* may be made on pocket-sized pieces of paper, while she may choose a large sheet of paper cut from a roll for a painting such as *Cormorants*. Using paper from a roll gives her the freedom to vary the shape easily without any wastage: 'It's very important that the shape of the painting suits the subject.'

Kim rarely bothers to pre-stretch paper. She has had difficulties from time to time with very large sheets cockling, but has her own method for avoiding this problem. Having cut a large sheet from a roll, she simply attaches the dry paper to a large board with drawing pins, sometimes reinforcing the line of pins with masking tape. She then paints directly onto this and the paper eventually dries out flat. Kim paints with the board vertical or horizontal, depending on how she needs to control the flow of paint. Large watercolours such as *Cormorants* are often painted with the paper on the floor.

OBSERVATION

Kim finds that watching the movements of a bird before putting pencil to paper is a prerequisite to successful drawing, and she often simply observes for several minutes before recording anything on paper. She then tries to draw the bird when it is sitting still between movements. She draws rapidly to freeze essential postures and forms in her mind's eye, gradually gathering more information to develop the bird's characteristics, the shape of its bill and feet and details of its plumage. She also records the way the light falls on the bird to build up its form: 'I watch and then quickly fix a pose it has made, trying to put down what it is that makes that bird special.'

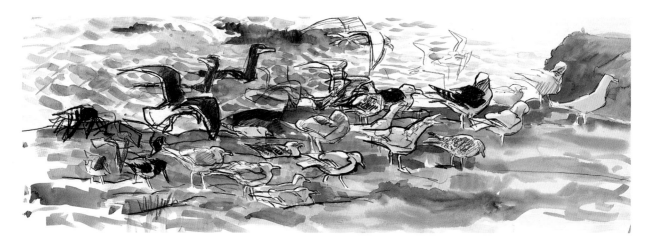

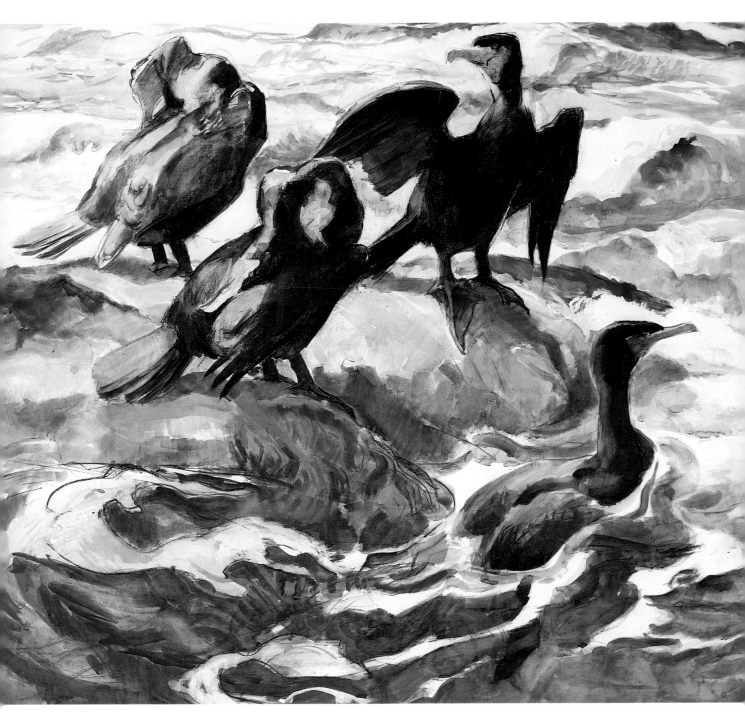

Kim never uses a camera to record bird movements simply because she enjoys drawing and painting her subject and using sketches and observations as a kicking-off point for other work. 'It's easier to create atmosphere, noise and movement in a watercolour, and it's faster than photography too.'

She views her subjects both with the naked eye and with the help of a telescope or binoculars. There are hides around Bardsey Island but Kim prefers to work outside them: 'If you sit quietly for a while the birds relax and you can get good views with binoculars.' There is a fine balance between being close enough and

being too close. Sometimes it is essential not to disturb the birds, and they must be viewed from a distance with a good telescope. This is particularly important with rare or nesting birds, such as those Kim painted in *Peregrine Falcon, Chicks in Nest*.

Although Kim makes no claim to be a specialist on bird anatomy or a 'field guide' illustrator, she has studied dead birds and their skeletons. She sees this as an exercise in observation. When drawing or painting in the field she can recall information gathered in the past. Each individual sketch and note contributes to a gradual accumulation of useful knowledge.

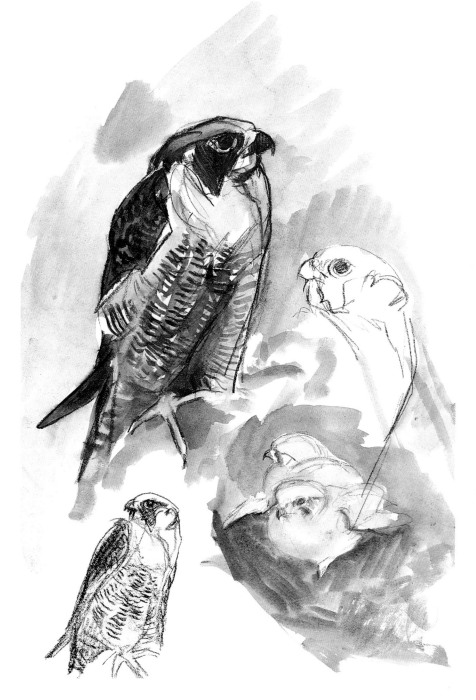

◀ Peregrine Falcon, Chicks in Nest
510 × 325 mm $\left(20 × 12\frac{3}{4}\,in\right)$
This dramatic bird requires a powerful visual description, and Kim has used compressed charcoal and watercolour on sugar paper. She studied her subject by watching through a telescope so as not to disturb the nest site

▶ Stonechat, Linnet, Spotted Flycatcher, Sheep
565 × 380 mm $\left(22\frac{1}{4} × 15\,in\right)$
With her accumulated knowledge of bird skeletons, Kim is always aware of how the underlying forms of the bird can be hidden or disguised by feathers and plumage patterns. This understanding of anatomy gives her the confidence to draw rapid assured lines. The studies were painted outdoors looking through binoculars and using a graphite stick and watercolour on absorbent printmaking paper. Initially, she drew out a rectangle and started to paint the stonechat, when a linnet arrived. She then worked from one to the other until the light began to fade

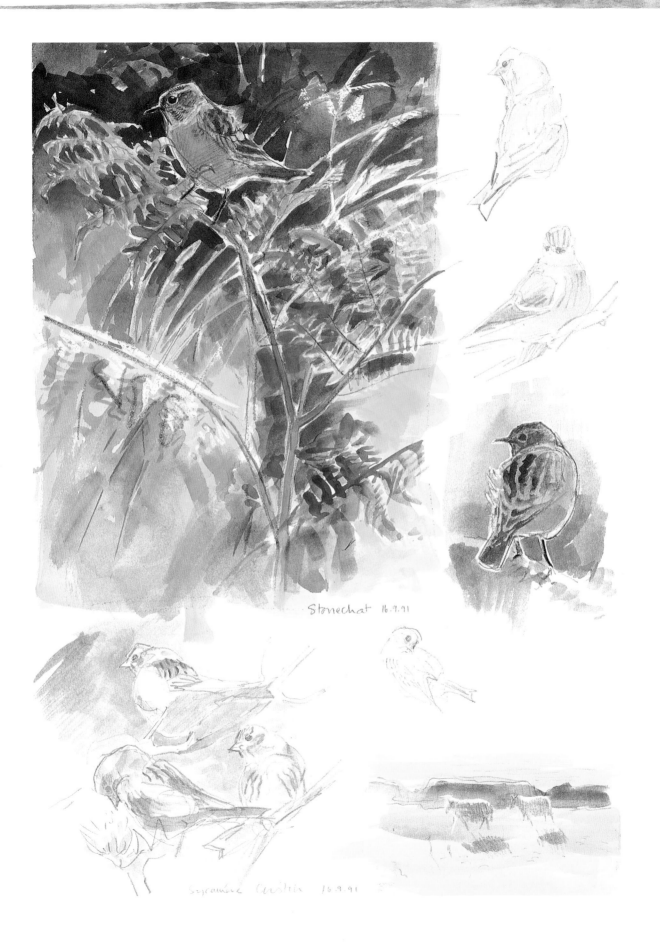

Stonechat 16.9.91

Sycamore Coustin 16.9.91

TECHNIQUES AND WORKING METHODS

'You have to be something of an opportunist when birds are your subject. You must take advantage of the unexpected – a bird feeding or bathing perhaps. Nor can you let the weather interfere. It might be a sight you will never see again or have the chance to paint again.'

The feeding birds in *Gannets* (below) provided just such an opportunity to which Kim responded immediately, rushing from the house to take a closer look.

For *Gannets* Kim made a rapid drawing with pencil and then added wax, using a white candle. Wax repels the watercolour to produce a granular texture and allows the light of the white paper to break through the paint, enlivening the sketch. Kim finds this wax-resist technique particularly useful for creating a sense of energy and movement for effects such as the crashing waves in the sea during a gale. *Fulmars* (opposite) was drawn with water-resisting black wax crayon and watercolour. There is always an element of chance when using wax-resist methods, and the result can be unpredictable: 'You never quite know what will happen until the watercolour is brushed on.'

Gannets

220 × 320 mm (8¾ × 12½ in)
These feeding gannets were captured in a rapid sketch using pencil, wax candle and watercolour on thick cartridge paper. In this small sketch Kim was more concerned with trying to capture the sense of speed, noise and splashing rather than specific details

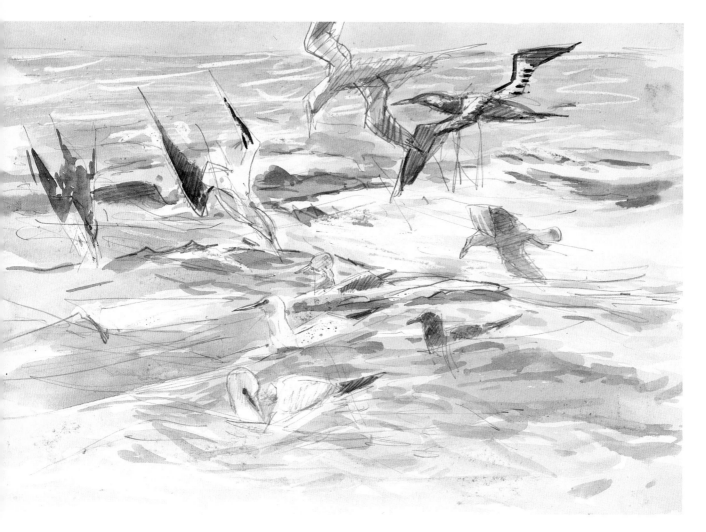

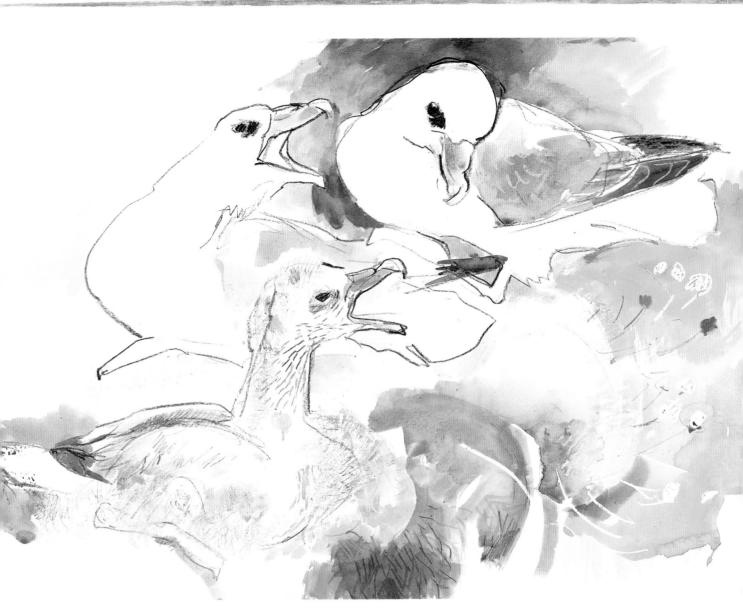

Fulmars

445 × 640 mm (17½ × 25¼ in)
Kim combined black, grey and
white wax crayons with
watercolour to sketch these
fulmars at a nesting site.
The birds are created with
amazing economy of line.
You can sense the roundness
of their forms because of
the delicate inflections in
their outlines

ATMOSPHERE

Bad weather, even rain, does not prevent Kim working outdoors. Braving the elements is often the only way to capture birds in their natural environnment. She likes to try and incorporate a sense of the prevailing weather into her painting without actually recording the 'scenery': 'You can capture the essence of the weather by the quality of the light itself. Just by choosing the right colour for the sea you can convey the sense of a hot sunny day or a cold wet gloomy one.' In fact, because

Kim's paintings often focus on the sculptural form of the birds, emphasizing the chiaroscuro effects of light and shadow, they can appear as if painted on a sunny day, even if that is not the case. By carefully manipulating the other colours in the painting – of the sea, the sky or the ground, for example – Kim can create different atmospheres, and still retain the strong form of the bird.

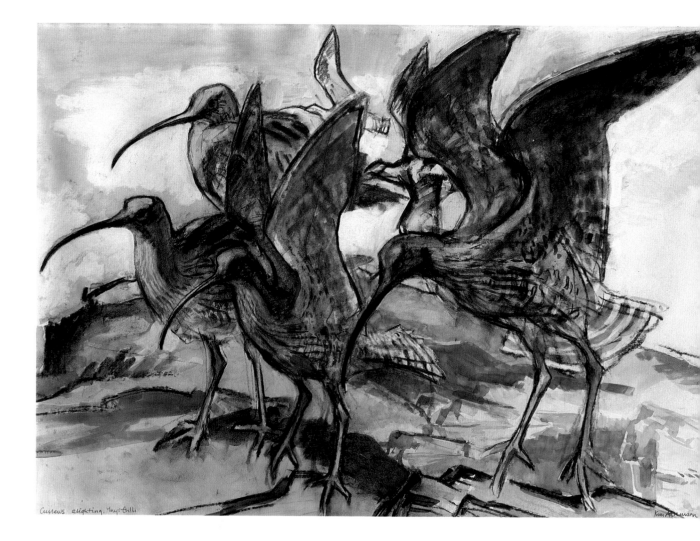

Curlews alighting. Ynys-Enlli

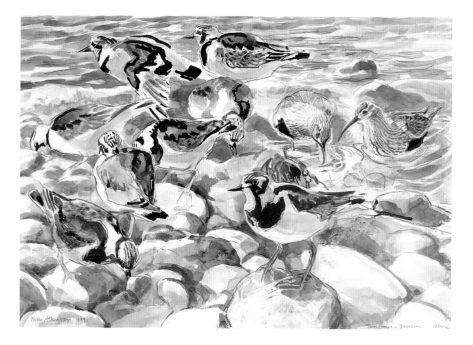

◀ Turnstones

$445 \times 655\ mm\ \left(17\frac{1}{2} \times 25\frac{3}{4}\ in\right)$

The turnstones, with two dunlin on the right, were painted in the studio from field sketches, using pencil, wax crayon, ink and watercolour. The painting is full of pattern, the camouflaged birds mingling with the pebbles and the dappled light. Kim has managed to express the birds' intimate relationship with their environment

◄ Curlews

610 × 865 mm (24 × 34 in)
This large composition is
based on a series of sketches
that had been done outdoors.
Kim worked on this painting
in the studio with charcoal,
watercolour and white
emulsion paint. It was not
only the shapes and plumage
of these curlews landing
cautiously on the rocks that
engaged her interest while
working on this watercolour,
but the challenge of trying
to convey a feeling of
weightlessness and the
buoyancy of flight

IN THE STUDIO

Kim does not always paint outdoors. The large painting *Curlews* (opposite) was started in near darkness one evening in the studio. An initial bold charcoal drawing took about thirty minutes and she then applied watercolour directly without fixing the drawing. Kim developed the picture sporadically over a period of a few days, blue-grey and ochre washes being followed by more charcoal and then further washes of colour. In places she used small amounts of white emulsion to edit out lines and tones and retrieve the whiteness of the paper: 'I am fighting a constant impulse to make my pictures as busy as possible, trying to be brave enough to leave things out.'

Back at the studio after a day's work in the field Kim might feel unhappy with the overall quality of a particular sketch, but will not discard it. Since it was made outside it usually contains some element that could provide useful reference. Paintings done in the studio are often based on a series of sketches from the field and, once started, may require more visual information.

In that case Kim will go out and make specific studies – for example, of water – or sift through earlier sketches. Occasionally a painting that is exciting on a small scale does not work at all as a larger version and so she will abandon it.

THE ESSENCE OF A PAINTING

Kim usually has a number of paintings and drawings in progress at any one time, often based on a similar theme. However, although she might work on larger paintings in stages she never leaves them for too long, otherwise she loses interest. The painting has to be exciting and energetic; too much time spent on it can take away its spontaneity.

Sometimes the quickest, least considered painting can say more than one Kim has spent days struggling with. After spending several hours wrestling with different sketches of bar-tailed godwits, for example, all of a sudden one came up trumps. *Bar-tailed Godwits* (below) captures the life and elegance of the birds in a delicate light. It is painted with seemingly effortless technique.

Bar-tailed Godwits

290 × 455 mm (11½ × 18 in)
Pencil, compressed charcoal
and watercolour are blended
by Kim with great delicacy in
a picture that is full of
confidence. The moving birds
are caught in mid-action by
decisive lines and brush
strokes. The whole painting is
full of sunlight and animated
elegant movement

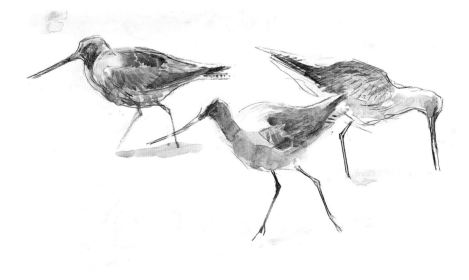

MASTERCLASS
with Adrian Berg

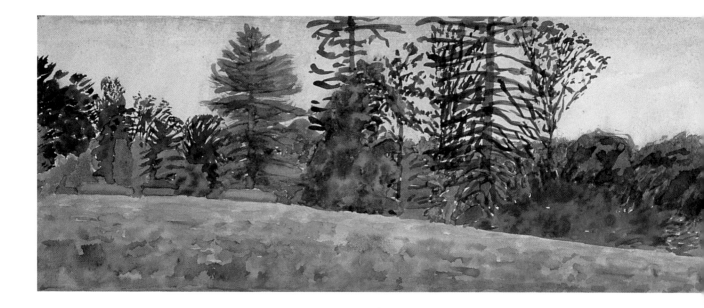

Adrian Berg has not always displayed great enthusiasm for painting watercolours. As a child he was given several watercolour sets but found he could produce little with them. Coloured crayons took precedence at this early stage and later when he started painting 'seriously' he worked predominantly in oils. When he became an art student in London in the latter half of the 1950s, watercolour was an unfashionable medium, though one particular tutor, Douglas Holden, recommended it to Adrian.

Holden encouraged students to work outdoors with watercolours in combination with pen and ink, and fostered a positive, robust approach, stressing the importance of avoiding over-precise detail.

Later as a student at the Royal College of Art, Adrian continued to work mostly with oil paints. He cannot remember using watercolour there, but in 1961 someone made a film of RCA students (with a commentary by David Hockney) and Adrian features in it, holding a pan of watercolours!

He continued to experiment with watercolour on and off for twenty years or so, often travelling to Kew Gardens, near London, to paint outdoors in good weather. The pleasure of watercolour was closely linked to a day away from the city and the studio environment. It was not until 1981 and a painting expedition to the Lake District that Adrian started to achieve results with watercolour that excited him.

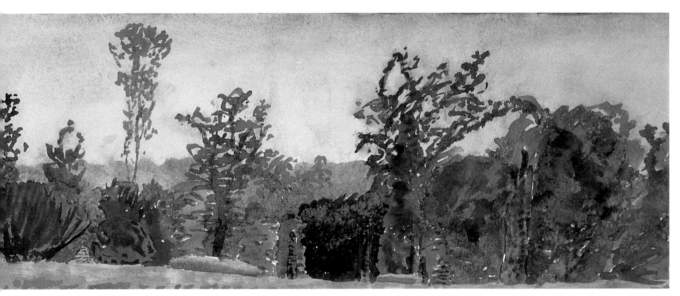

The Pinetum, Nymans, 14 and 16 August 1988
205 × 1015 mm (8 × 40 in)
Adrian has many favourite haunts he travels to during the summer to paint watercolours. He has made regular visits to the Lake District and also to numerous great parks and gardens throughout Britain. Nymans, a well-known West Sussex garden, is among them and this painting in two parts is one of a number of panoramic views painted there. Like most of Adrian's watercolours it was painted outdoors on smooth hot-pressed paper and is carefully dated. He has explored panoramic watercolours painted on more than two separate sheets and over longer periods of time too. The purpose of these wide-angle narrow compositions is to encourage us to scan across the view, taking in the patterns, textures and rhythms as we move, just as we would in the actual location

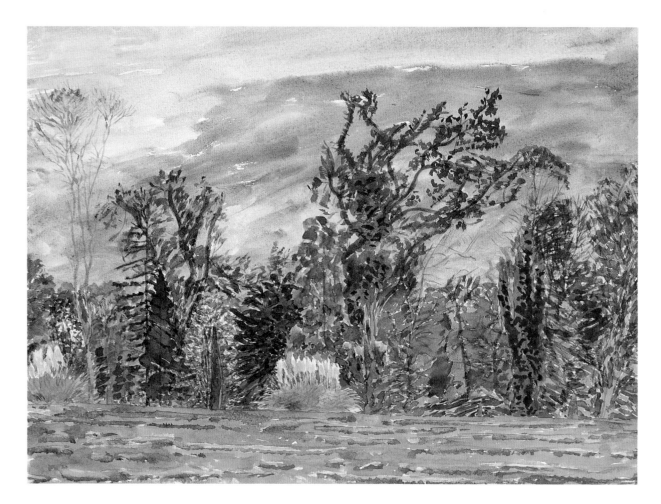

TRAVELLING AND PAINTING

Adrian travels a great deal around Britain and has honed both equipment and procedure to make the most of his time and energy. Through experience he has learnt what is practical, not simply in terms of how much he can comfortably carry up a mountain for instance, but also in terms of choosing what to paint when he reaches his final destination. First he avoids a subject that would be impossible to paint in the time available. He also consciously avoids a subject that does not present sufficient challenge or is similar to paintings he has already done. He seeks to find a balance between these extremes, always very conscious of the fact that in choosing one spot he has passed

alternatives and that limited time prevents him from considering too many possibilities. Once in his chosen location, though, whatever the weather, Adrian is always prepared to paint. Having started work, there is nothing for it but to see the painting through to its conclusion, 'or why else bother making all the effort?'

Painting involves pushing each work one step further, and improving each time. Adrian stresses how important it is to revisit places. After numerous visits to a location he usually returns to discover something more that he had previously missed. From a logistical point of view returning also helps iron out any problems of how to get there and return home. If you know how far you have to walk and at what

◄ The Pinetum, Nymans, 18 October 1988

305 × 405 mm (12 × 16 in)
Painted two months later than the panorama on pages 46–7, on a return visit to Nymans, this watercolour features some of the same trees from the right-hand panel of the earlier painting, but from a closer viewpoint. Adrian's handling of the paint here is also more animated, the brush work of the trees and sky suggesting a windy day. Foliage is beginning to change colour and fall away to reveal linear branch patterns. It is exciting to get to know a group of trees really well and chart their changes in response to the seasons. Late autumn is particularly interesting because what were dense bushes of green foliage in summer suddenly start to change colour

► Wakehurst Place, 1 August 1991

335 × 500 mm (13¼ × 19¾ in)

► Wakehurst Place, 2 August 1991

335 × 500 mm (13¼ × 19¾ in)
Both drawings were made with a dip-pen and Indian ink. They explore the complex patterns and densities of foliage and the sense of movement in the trees. Adrian also uses a small brush when drawing and, because there is no colour to preoccupy him, he can concentrate on exploring a range of marks and textures that will eventually feed into his watercolour treatment of similar species of trees

time you have to leave to catch the last train home then you can concentrate on painting. This is increasingly important to him as he chooses and favours places that are as a rule remote and not easily accessible.

EQUIPMENT

In keeping equipment to a minimum Adrian rarely takes both drawing and watercolour materials out with him. Extra drawing pads, pencils and ink are too much to carry along with umbrellas and a pullover. It can be quite a relief to take just drawing materials. He draws in a sketchbook folded right back on itself and held in this position by small clips. This makes it feel like a watercolour block and focuses attention on the single sheet of paper being used. He draws in pencil and ballpoint but has recently been re-exploring dip-pen and ink, as in *Wakehurst Place, 1 August 1991*. Drawings such as these have a calligraphic quality,

generating a sense of movement throughout the subject. This directness is becoming more important in his watercolours too.

Adrian used to carry a small steel tape measure with him and after choosing his view would use the tape to 'sight-size' relative proportions. He marked down observations and established important shapes and the silhouette of the subject with a pencil. In this way the diminished size of distant hills and trees could also be 'measured' and distortion kept to a minimum. As he became more assured a paintbrush handle replaced the tape measure. More recently, however, he has abandoned both, finding that what had started out as an aid had become habitual and limiting: 'It became a crutch which must be thrown away if you want to walk.' Now he judges by eye and encourages a certain amount of spatial or proportional distortion. He no longer starts with a pencil and eraser, but begins a painting directly with a brush.

Adrian uses only two or three brushes regularly – those that make the most interesting mark and will also come to a good point. He does not feel it is necessary to use a good-quality brush for filling in, adding paint or water to the palette or lifting colour out of the painting. Generally he tries to paint with a brush that seems too big, as it stops him being too fussy about detail. He has a great passion for Chinese painting, but though he owns one or two oriental brushes and occasionally uses them, he feels that he has not yet learned to handle them in the correct way.

PAINTS AND PAPER

Adrian buys his paint in the form of whole pans and cuts them in half

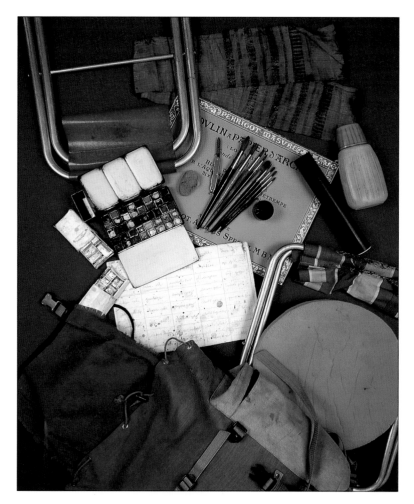

with a penknife to fit his box. He dislikes tubes because the tops can be so difficult to unscrew, especially outdoors in cold weather; it can be maddening and wasteful if the tube tears. His paintbox is crammed with a range of primary colours, plus greens and earth colours. He advises that you should use whatever colours you like and enjoys trying out unfamiliar hues. In the past he always favoured Mars colours to the traditional earth colours – for example, Mars Violet instead of Raw Umber and Mars Yellow instead of Yellow Ochre – but has now reversed his preferences.

Colours are mixed in the flaps of a small paintbox and applied directly to the painting. Adrian used to test colours out by making marks around

Painting equipment
This photograph shows the equipment that Adrian has decided is essential for his excursions and the small rucksack into which it all fits. The chart in the centre of the photograph lists the colours that he likes to include in his paintbox. The watercolour block contains one of his favourite smooth papers

Studio notebook

This large notebook sits open on a table top in Adrian's studio and is full of diagrams and meticulous notes tabulating the colours he uses in his oil paintings. It is a fascinating diary of years of accumulated colour knowledge that can be consulted at any time if he wants to repeat specific colour mixtures and juxtapositions. It is only when you enter the often private world of an artist's studio that you discover the idiosyncratic methods that are an integral part of his or her work

the edge of the painting. He no longer feels the need to do this, but is extremely thorough in making sure that a colour is right. The photograph above shows a large notebook that he uses in the studio when working with oil colours; every single colour mixture is listed for each painting with meticulous care. This is all part of Adrian's great depth of knowledge about colour in general and its behaviour, and it contributes to the ease of 'local colour' mixing when working with watercolour.

Adrian prefers smooth or 'fast' paper, but he also explores other surface qualities. He usually buys paper in the form of ready-made watercolour blocks, which he really enjoys using because they can be

turned around easily and worked on from any angle. These blocks do away with the need for boards or tape and can be worked on up to the edges like canvases. Compared to his work on canvas Adrian's watercolours are small, usually about 305 × 405 mm (12 × 16 in). A large oil painting might be up to 3 m (10 feet) square. He says it is easier to work on a large scale because at least it has size going for it 'whereas if it's small it has to be good.'

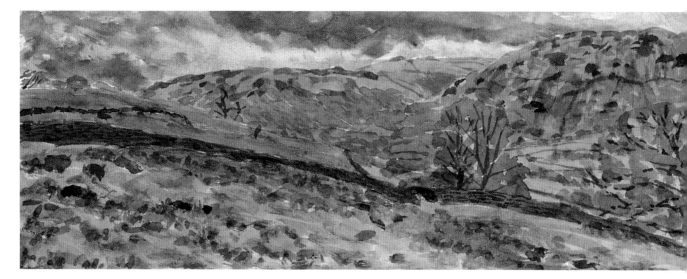

▲ Seatoller,
16 August 1989
150 × 800 mm ($6 × 31\frac{1}{2}$ in)
Adrian does not use any 'special' watercolour techniques but applies colour directly with small and medium-sized sable brushes. He occasionally uses a small sponge to dab colour onto or off the painting. In starting this painting he divided the sheet of his watercolour block horizontally along the centre with a soft pencil. Faint pencil marks were then used to position the main features, the left half of the panorama being sketched out in the top portion of the initial division, the right half in the lower. When Adrian starts to paint he endeavours to get colour, tone and shape right first time, so he does not start out with the intention of building up the painting in layers. The first brush strokes of this painting established the trees. The paler yellow hues of the valley floor followed later, being washed over white spaces left ready for them. The village of Seatoller and the sky were added in the final stages of the painting; Adrian used a degree of invention in devising a suitable sky from the constantly changing sky of that particular day. Later, when dry, the painting was cut along the initial central pencil line and rejoined to make the panoramic format. Slight adjustments were made to ensure a smooth junction of forms where the two sheets came together

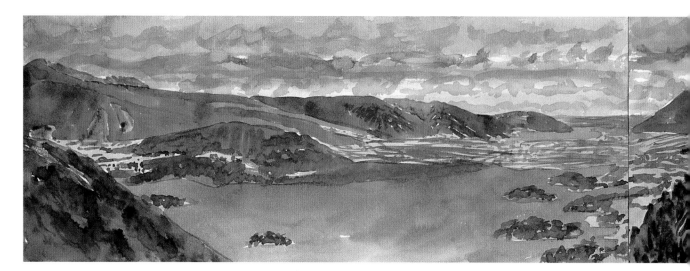

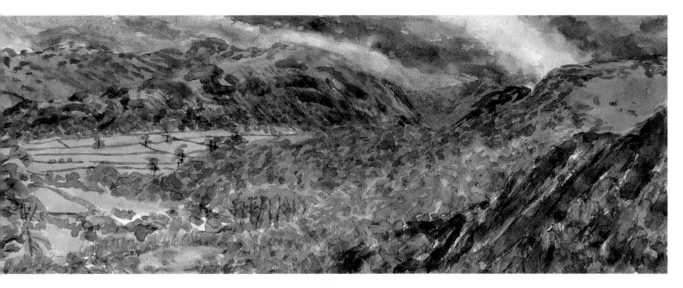

KEEPING THE PAINTING FRESH

A watercolour such as *Seatoller, 16 August 1989* is completed on site, and often classed as finished when time intervenes and Adrian has to catch the last bus home. With some very complex paintings work might continue back at the hotel on his return or, much later, at his studio.

The painting of Adrian's open-air, topographical watercolours coexists with the painting of large-scale oil paintings in his studio. The watercolours are not painted as studies for studio works but their immediacy and vitality feeds into and keeps the studio compositions fresh. Adrian believes that it is essential to balance observations of the environment with the formal compositional aspects of painting. The large studio paintings might record the experience of the same landscape through the changing seasons or assemble different facets of a place. As he says: 'They are not confined to what was on offer at any one time.' Similarly he has explored long panoramic watercolours that present the viewer with a lot more than a single glance or a photographic snapshot could provide. In *Derwent Water, Bassenthwaite Lake and Skiddaw from Cat Ghyll, 8 September 1987* Adrian has compiled a horizontal

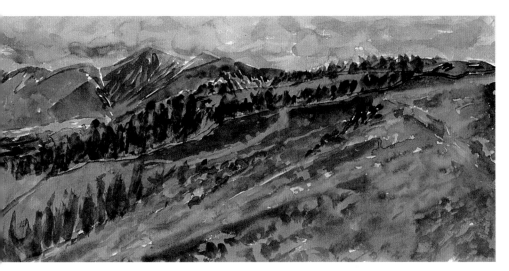

▼ Derwent Water, Bassenthwaite Lake and Skiddaw from Cat Ghyll, 8 September 1987
190 × 915 mm $\left(7\frac{1}{2} × 36\ in\right)$ Our sense of space and our sense of scale are skilfully teased as our eyes travel across this panorama painted in one session in the English Lake District. Viewpoints like this one can involve a fairly arduous journey and Adrian plans his painting visits meticulously so that he can make the most of actual painting time. The whole painting is suffused with a mixture of delicate yellow light and blue reflected light from the great expanses of sky and water. Simple flat washes of transparent colour are exploited to create colourful luminous shadows on the distant mountains

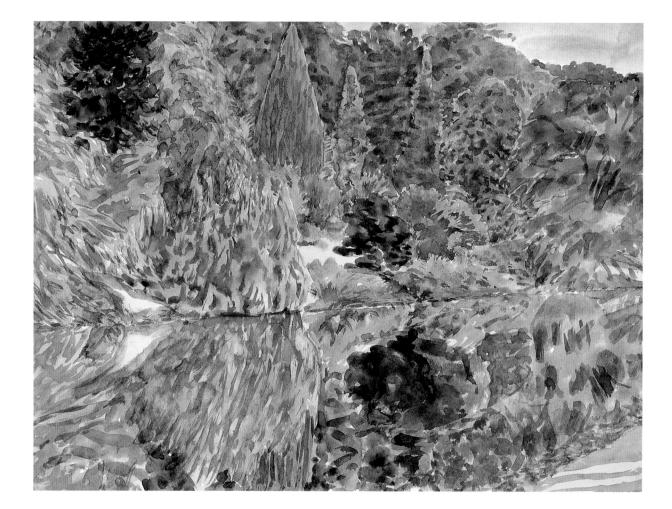

Stourhead,
10 August 1990
305 × 405 mm (12 × 16 in)

scroll-like dossier of the landscape's rhythms on a particular day. We can sense the movement of the clouds as time passes and the changes of light and shadow.

The watercolours are always full-blown compositions. Adrian does not paint studies of individual components, such as trees for instance. He feels that anyone painting studies must suppose that there is something intrinsic in the subject that will repay time spent 'getting to know it'. For him this is only partially true. However well you may know a subject does not necessarily mean that you can make a picture of it; and similarly, knowing little of a subject does not prevent you from producing a good painting. He finds photographic studies even less useful:

'Taking numerous photographs as preliminaries to a painting doesn't actually bring you any closer to starting.'

Adrian believes that you can only learn about watercolour by painting with it and gradually taking small steps towards improvement. He avoids making his paintings too mechanical, too 'rule' based. For the result to be new and exciting, experiments to find new ways of tackling well-known subjects are a must. He thinks that it is essential to balance whatever you glean from books on technique with your own spontaneous efforts: 'otherwise you end up with something that has all the freshness of a kipper!'

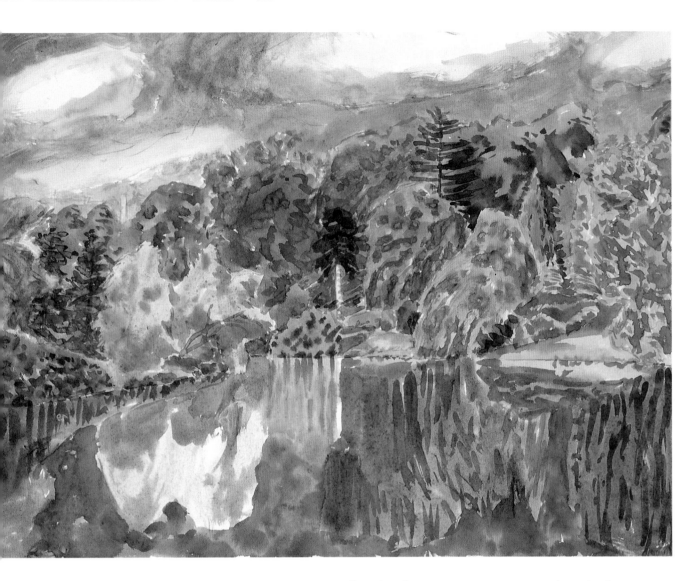

Stourhead,
16 August 1990
305 × 405 mm (12 × 16 in)
In a sequence of paintings spanning a number of fine August days Adrian adopted a squarer shape of paper to explore a group of trees surrounding water (OPPOSITE and ABOVE). The subject presented a chance to depict the ornamental foliage of the mixed species of trees with their inverted reflections. The exuberant patterns of the trees change slightly in the reflected symmetry, appearing slightly elongated. Paintings like these give Adrian the chance not only to display his understanding of natural forms but also to revel in the formal, compositional aspects of painting. A sequential group of paintings of the same subject also generates a freedom to experiment with variations from one image to the next. Adrian creates a complex assemblage of shapes, colours and ornament without losing immediacy and freshness of impact

MASTERCLASS
with John Blockley

John Blockley has always painted in watercolour, from as early as he can recall. He used to paint with oils too, but gradually watercolour took over. Its immediacy and the sense of risk it creates are what captivate him – its 'finger-nail biting' qualities.

Like many artists John found watercolour the ideal medium for landscape painting and early on in his career he scorned the idea of working with it indoors. Experiencing the weather and 'hearing the corn stubble' underfoot were all part of painting a landscape. The painting had to be done outdoors and it was never fiddled with when back at the studio. But, as his experience has grown and his watercolour techniques have evolved, his practice has changed. Now, though still steeped in the landscape, he rarely paints outdoors. The particular watercolour techniques that John has perfected require a bath of water and a hairdryer – two very practical reasons for painting landscapes in the studio.

John's paintings rely on invention, backed up by years of experience 'in the field'. He dislikes the idea of a subject dictating to him and has discovered that by working in the studio away from the landscape he can be more selective and more imaginative. His paintings never lose their link to the original subject but by distancing himself from it he is free to explore radically different treatments. He finds innovative solutions to express different moods, seasons, weather conditions and light effects. Whenever he paints he takes full advantage of the unexpected and is prepared to change direction completely.

▶ Summer Trees
190 × 180 mm ($7\frac{1}{2} \times 7$ in)
Summer light and the spaces between trees and foliage are as much a part of this watercolour as the trees themselves. It is a wonderful mixture of washed-out patches of pale blue light and dark, bold, blue-green tree shapes interspersed with calligraphic pen strokes describing the branches. The foreground is kept uncluttered and dark, so that it does not compete for attention but leads us into the trees and the light – the main focus of the painting

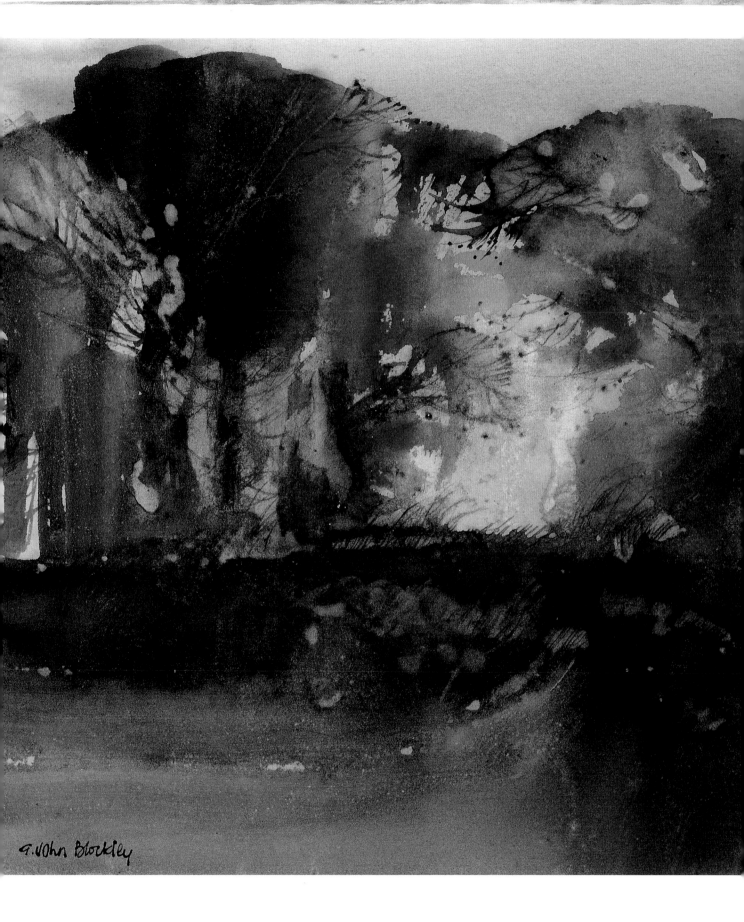

G. John Blockley

Demolition

205 × 480 mm (8 × 19 in)
In a painting like this
although there is considerable
detail, John believes that the
less drawing he does the better
the watercolour will be. Too
much detailed drawing can
stifle the imagination. The sky
and foreground are kept
simple, in contrast to the busy
buildings. The paints John
used to explore this colourful
ramshackle subject were
Burnt Umber, Payne's
Grey, Hooker's Green and
Alizarin Crimson

INITIAL DRAWINGS

Fresh visual information is gathered outdoors by drawing, usually with a pencil or graphite stick that can produce broad wash-like tones. These drawings are totally functional and are often intelligible only to John himself! Back at the studio he uses them as a starting point to spark off ideas and inspire fresh interpretations. He draws in sketchbooks or on scraps of paper such as old envelopes and also makes written notes about colour or texture. Because he paints in the studio every day, these drawings and notes are very important as a source of inspiration. The painting *Demolition* (above) started life as a rapid pencil-line outdoor sketch. The initial sketch established the position of the horizon and carefully recorded the angles, slopes and idiosyncratic shapes of the buildings. In the studio this profile was all that was needed and once it was established John was free to explore the subject in terms of watercolour.

PREPARING TO PAINT

John remembers how he would travel far afield to a particular location to paint a specific subject, perhaps a landscape or buildings, but would then spend all day walking around unable to decide where to start. Now, when he is drawing outside he starts 'almost anywhere' and has discovered that the least obvious subject might well produce the best painting. It is very much a case of being continually open-minded. A painting session in the studio might not start with a specific subject in mind, but simply by choosing just three colours and then seeing what can be done with them: 'Every so often I think back to a colour that I couldn't get on with and I just start with it, trying not to play safe.'

He often paints flowers in pastel too. He is not interested in botanical accuracy but is fascinated by their qualities of shape, light and colour, as illustrated in *Flowers – Red* (opposite). The vase of flowers, like the landscape, is a starting point – a springboard from which to explore a drama of pattern, colour and texture.

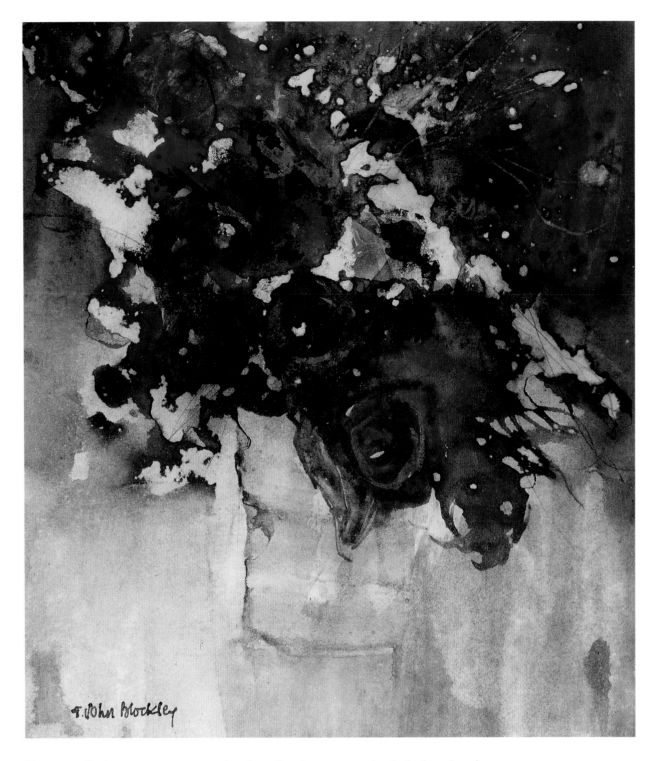

Flowers – Red

165 × 145 mm (6½ × 5¾ in)
John paints a vase of flowers like this for their colour and not for their botanical detail. He used smooth paper on which wash control is not *easy but does allow for interesting modulations of colour. John enjoys working spontaneously and in this painting the petal shapes are fluid and blurred though interspersed with some* *hard-edged patches of strong light. John blotted the areas of softer light to convey the translucence of the petals*

Inspiration is an essential pre-requisite to a painting session. John listens to jazz and classical music while working in the studio which he shares. He enjoys the presence of another artist just as he likes the hustle and bustle of the street outside. He tries to transmit his physical energy into his watercolours and paints standing up, often as if he was conducting the music he is listening to. Painting, for him, is certainly not a sedentary business; it takes nervous energy and is exhausting. 'If I was playing football I would be running down the right wing,' is John's metaphor.

The paper he uses is usually light-weight, and medium or smooth surfaced. He prefers this because it can take a wash but is also suitable for line work. It is not stretched at this stage because of the washing-out process it will go through later, when it will inevitably cockle.

PAINTS AND EQUIPMENT

Fresh tube colours are squeezed out onto a large palette at the start of each session. The palette is a large plastic one with compartments. John places the palette on top of a table that has been painted white. As can be seen in the photograph this white surface serves as an extension to the palette and he considers both to be inspirational. Although he has a few sables, his brush collection is a Spartan one. He favours inexpensive house-decorating brushes, especially for broad washes, and uses them in sizes up to 65 mm ($2\frac{1}{2}$ in) wide. For line work he uses a dip-pen loaded with watercolour by means of a small brush. *Summer Trees* (see page 57) shows just what can be done with this simple combination of tools and by knowing how to exploit not only watercolour but water itself.

Palette and paintbrush
John insists that there is organization within the apparent chaos of his palette. He does clean areas of it from time to time, but views the accumulated patterns of coloured marks as a source of inspiration

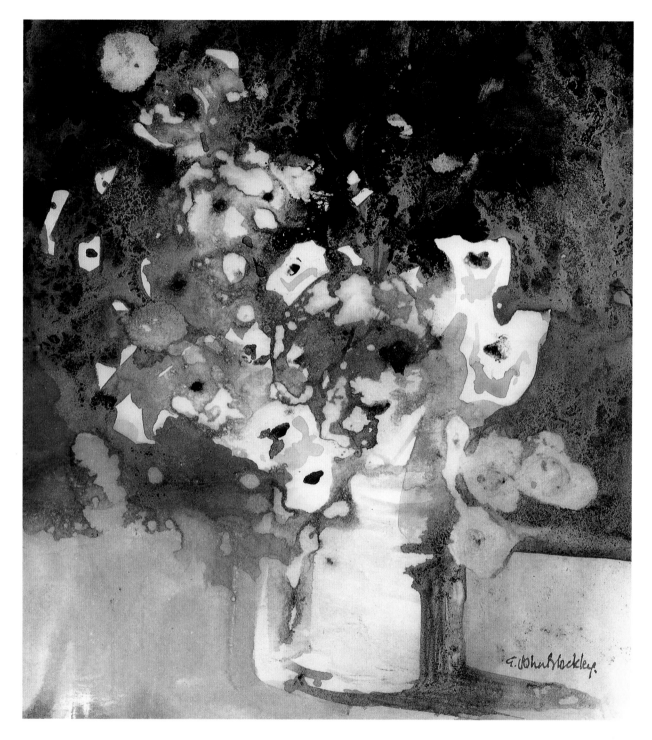

Flowers – White

165 × 145 mm $\left(6\frac{1}{2} × 5\frac{3}{4}\, in\right)$
*John associates closely
with his subject whether
it is flowers, figures or
landscape. He likes to express
imaginatively its particular
qualities of shape, colour or
texture, or the lighting and
associated mood. One element
common to all his work with
watercolour is the way in
which he employs techniques
for removing colour as
an integral part of building
up a painting*

WORKING WITH WATER

For John, water is not just the vehicle for the pigment in the paint but is also a tool with which to manipulate the paint, as is a brush. His method of painting involves adding and removing colour, and water plays a central role. Painting depends not only on the continual building up of the paint layer but also on taking away, editing out or paring down. John spends as much time removing colour as he does applying it. Many watercolour painters use a brush, sponge or tissue to lift wet paint from the paper. It is a standard technique for reintroducing lighter tones into a painting that has become too dark, and it can be used to soften edges or clear away paint to allow corrections to be made. John's process is more radical than that and more dramatic.

When he starts painting John deliberately makes areas of the painting wetter than others. This is controlled by the quantity of colour washes applied and by the selective addition of clean water to the already wet painting. He then takes a hairdryer and works it over the painting, rapidly drying some parts and leaving others wet. Next follows the dramatic stage where the whole painting is plunged into a bath of water. This dousing causes the paint that was still wet to float away from the paper while the dried paint remains intact. The 'washing' can be done in different ways to obtain different results. A gentle immersion will remove only the wet paint, but if the water is agitated by hand or the painting rubbed, more watercolour will lift off. If the painting is held under a tap or a shower the mechanical action of the water will remove even more paint. Alternatively, more delicate effects can be created by flicking drops of water onto the painting and letting them dribble across it. Thick watercolour can also be applied in lines and then more dilute colour washed over it. As soon as the wash is dry the painting can be 'hosed' down and the thick paint which remained moist dissolves quickly and is washed away to reveal white lines.

UNEXPECTED RESULTS

Although with experience this immersion technique can be controlled fairly carefully, there is always an unpredictable element, and John delights in this. The action of the water is allowed to contribute to the evolution of the painting. It is not a means of correcting the applied paint but is a positive creative ingredient, an essential component of the painting process right from the start. When the painting is removed from the water it is always a surprise and presents the challenge of how to develop its potential, how to interpret the shapes and textures.

This technique produces a pattern of light and dark shapes but with another unique quality. The edges of the washed-out areas have a particular appearance. They seem to be poised between being described as 'hard' and 'soft'. John says he sees the world in terms of 'edges' – the transition from one shape to another. Some shapes stand out, while others blend into each other. He works on his watercolours to explore these subtle inter-relationships. The painting *Hills, Autumn* shows how the washed-out passages can be manipulated to produce a range of edges. After washing, edges were developed even more sensitively using conventional wet-into-wet and blotting techniques. With skilful and

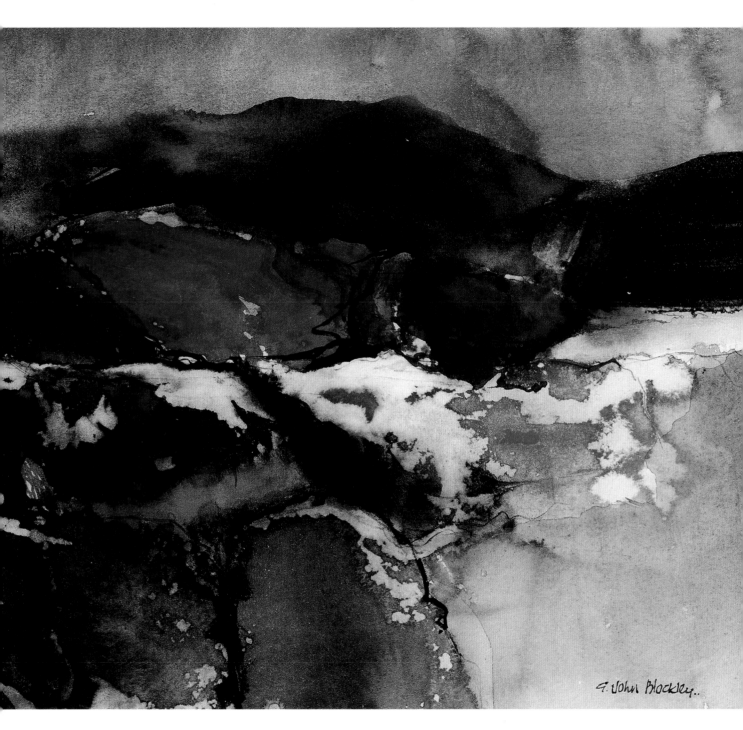

G. John Blockley..

inspired painting almost random shapes can be transformed into mountains, fields, clouds and boulders speckled with light. The subject, easily recognizable, is never described too literally and the viewer is invited to unravel the painting and use his or her own imagination to interpret the subject.

Hills, Autumn
205 × 225 mm (8 × 9 in)
John always experiences the same fascination at watching colour float off a painting as it is immersed in water. Here the results were enhanced with further washes of colour to create rich autumnal hues.

The painting creates an atmosphere of damp weather; the saturated ground displays much stronger colour than when dry. The inky distant mountain melts into the indigo sky. Colours are encouraged to flow together in places, yet clearly separated in others

63

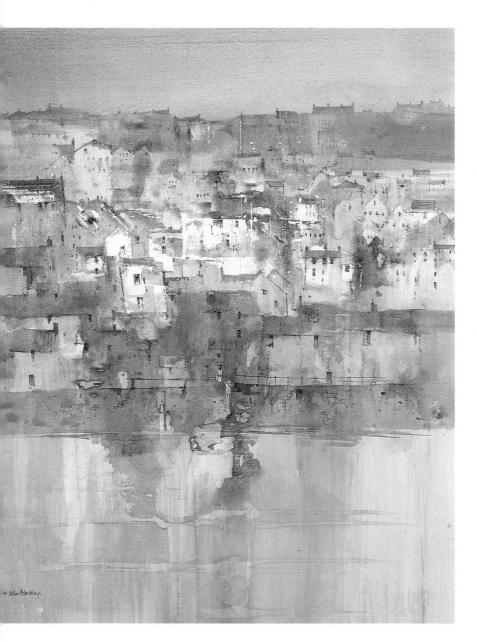

The washing-out technique is used to create not only broad or random effects, but also more precise details. In the watercolour *Harbour Cottages* the white cottages were the result of a finer, localized application of the technique. The small, carefully controlled shapes that resulted were then transformed into buildings by use of horizontal brush strokes to suggest roofs and a few inventive marks to create the impression of windows.

CREATING TEXTURE

John finds great pleasure in painting buildings and trying to recreate the texture of weathered stone. He uses another technique for this. The buildings in *Pembrokeshire Farm* (opposite) were created by an initial application of white acrylic paint, worked quickly and roughly onto the paper with a small painting knife to give the desired shape. Once dry the painting was then carried out, as normal, with watercolour. Starting with the background a mixture of Winsor Blue, Winsor Green and Warm Sepia was washed right across the paper and over the acrylic paint. A more dilute wash, leaving out the sepia, was applied over the rest of the foreground. After a moment or two a moist brush was used to remove most of the colour from the acrylic paint. It lifts off very easily from the non-absorbent acrylic, leaving behind traces of colour in the slight ridges made by the painting knife.

This technique was also used for the painting *Quay-side* (opposite). Here the acrylic paint was applied to produce a broken surface and less precise shapes to create an impression of the shimmering light reflected from the water.

Harbour Cottages

470 × 380 mm ($18\frac{1}{2}$ × 15 in)
Painting is a process of selection and interpretation. John has drawn and painted many harbour scenes because of their potential; buildings, boats and water always provide interesting subject matter. Here he has created a placid mood concentrating on the overlapping geometric shapes of small houses hugging the hillside. Delicate washes of ochre and pale violet are animated by the orange roof tops and intermittent details of windows and texture. The simplified shapes are broken down in places by watery washes that create a sense of old weathered buildings

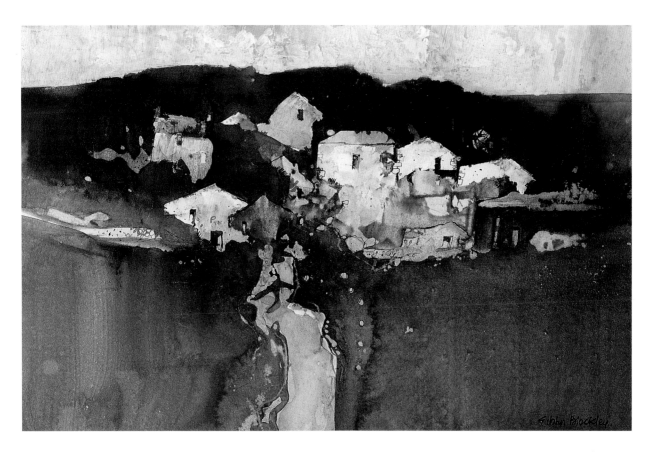

▲ Pembrokeshire Farm
150 × 255 mm (6 × 10 in)

▼ Quay-side
205 × 455 mm (8 × 18 in)

These two paintings illustrate John's different uses of white acrylic paint to produce specific textures in his watercolours. Both make use of the contrast between small fragmented shapes and textures and broad sweeping washes of colour. Alongside the textural effects the technique also creates sparkling qualities of light

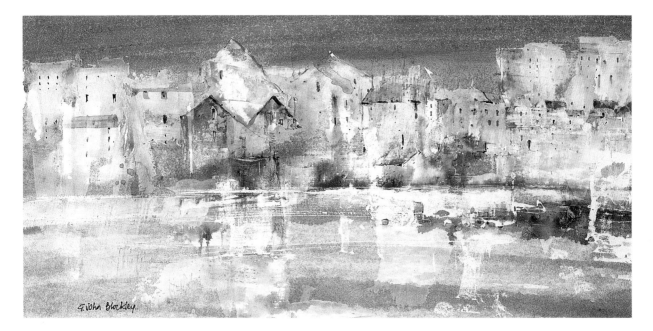

Late Evening

305 × 430 mm (12 × 17 in)
This landscape is suggested rather than described and is made up of horizontal bands of colour. At first glance it is not clear exactly where the evening sky starts. A single pale strip is poised vertically near the centre of the painting, creating a myriad of impressions. The viewer's imagination is allowed to mingle with John's to interpret this painting, picking out the features before nightfall closes in and conceals everything

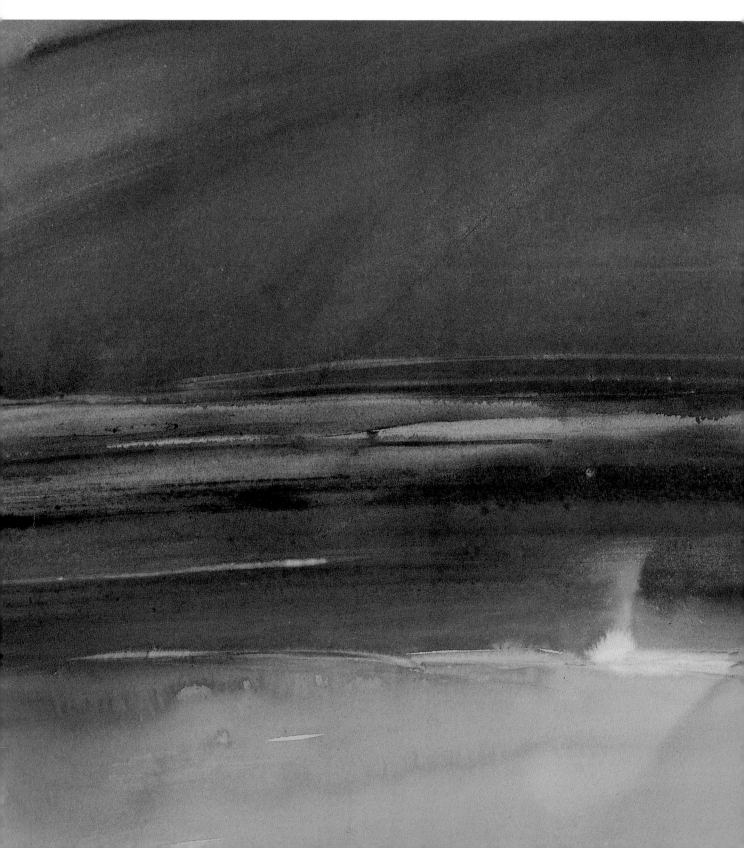

9. John Blockley.

FINISHING OFF

John does not know how he 'finishes' a painting and this is part of the excitement. At one time he would destroy work if he was not immediately completely satisfied with it. The techniques he uses now, however, enforce long intervals of drying time, which allow extensive contemplation of paintings in progress or already put to one side. He can also work on more than one painting at once or work on a pastel while watercolours are drying. Because of this, decisions on whether or not a painting is finished or worth keeping tend to be less immediate than in earlier days. Some watercolours are put to one side for months so that they can be evaluated with a fresh eye. This is a good way of discovering whether or not the painting still has the spark of excitement that originally produced it.

Like so many accomplished artists John is very pragmatic in his approach to paintings without this spark, ultimately consigning them to the bin. Portions of the painting that are exciting are simply cropped out and retained. They serve as good source material for new paintings or might even be developed themselves into smaller paintings.

As described earlier, watercolours are painted on unstretched paper because of the techniques John uses. They are stretched, however, once he has decided that they are finished. The completely dry painting is immersed in water again and drained off. John insists, 'that this can be done without any damage to the painting as long as the surface isn't actually rubbed'. The painting is then taped down to a board with gummed tape. The final result is a smooth flat watercolour that can be mounted and framed easily.

MASTERCLASS
with Cherryl Fountain

Cherryl Fountain's paintings display her fascination for recording the rich, colourful complexity of the visual world. She revels in building up highly detailed watercolours. The detail in these is held together by skilful composition which guides us into and around the painting. She was particularly interested in composition as an art student and was obsessed with Italian religious painting, renowned for its pictorial organization. This interest in Italian and Spanish art and subjects was further stimulated by bursaries awarded to her to travel and paint in these countries. She was able to 'make the places and subject matter my own'. Cherryl believes that it is fundamental to get to know a place really well before you can paint it properly.

Cherryl relies on drawing to experiment with composition and to 'home in' on her subject. She draws and paints a lot in sketchbooks, something that she has done since schooldays. Some sketches are very functional – just a few scribbled lines to sort out a composition or shape, or record a fleeting idea. Others are done for pure pleasure and become quite elaborate, such as the Spanish watercolour sketch opposite. Although she was pushed for time and had to rush this sketch she remembers really enjoying trying to paint the effect of the water. Drawings or watercolour sketches are also used to work out a good view and where to paint from. When out on location she might walk around the area for a couple of days with a sketchbook and the bare minimum of equipment, drawing from different vantage points to find out which places have potential for a picture.

▶ Painting from sketchbook
290 × 395 mm $\left(15\frac{1}{2} \times 11\frac{1}{2} \ in\right)$
What start out as simple sketches sometimes become elaborate paintings, like this sketchbook study of water made while Cherryl was travelling in Spain

Painting from sketchbook

210×290 mm $\left(8\frac{1}{4} \times 11\frac{1}{2} \text{ in}\right)$
Subjects like this view down a stone staircase in Perugia fascinate Cherryl. She enjoys the way that they create pathways into the distance, guiding the viewer through the painting

WORKING METHODS

Cherryl has made many painting visits to Italy and often painted in the historic town of Perugia. In the watercolour sketch above she was stunned by the incredible view down a staircase. Through this sketch she became interested in stairs and how they guide the eye into the painting. It was also a pleasure to paint all the stone and this led to other paintings in the area. So, although she might not re-use a particular sketch literally to compose another painting, what she discovers while doing it can lead to other exciting developments.

On one occasion Cherryl knocked on the door of a local convent following a hunch that they must have a good view and was taken to a room that not only had a distant view but also overlooked a beautiful garden!

View from the Aqueduct to the Università per Stranieri, overlooking a walled garden, was also painted in Perugia. This is typical of a series painted looking from the aqueduct in different directions and took about five days from start to finish: 'It was fun trying to record the different types of foliage, which included cherry, plum and pine in addition to a host of vegetables.' The pine needed many subtle shades of grey and blue-green to create the right effect. Cherryl knows that a painting of that size will take a long time and keeps to a strict timetable working from dawn until dusk.

View From the
Aqueduct to the
Università per Stranieri
560 × 420 mm (22 × 16½ in)
*Painted on smooth white paper
like most of Cherryl's
watercolours, this subject
sparkles with light and shade.
This was achieved by
establishing the paler colours
first in the form of basic
shapes. Shadows were then
established slowly, isolating
areas of light and gradually
defining more detailed shapes.
The sunlit leaves of the central
tree are picked out by
darkening and simplifying the
'negative' shapes surrounding
them. The foliage of the pine
tree is suggested with an
accumulation of small brush
strokes of different tones.
Patches of these are paler than
the buildings behind them and
you can see the basic white
shapes that Cherryl isolated
initially to place them in. This
shape now forms a halo of
light around the foliage,
creating the effect of being
illuminated from behind*

Having decided upon a comfortable vantage point and subject Cherryl will take along a full sheet of paper on a board and a small collapsible travel easel. The board and a small folding stool are usually bought locally. She also carries a large umbrella for painting in the rain or to use as a windbreak. She does not really enjoy working in public and finds that at least when painting abroad she can pretend not to understand over-persistent enquirers. Lately she has discovered that wearing a personal stereo is even more effective!

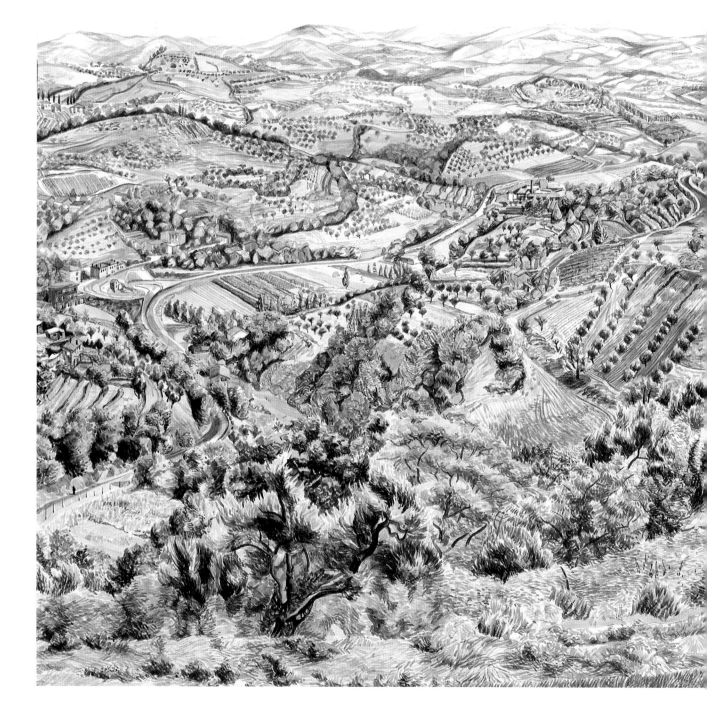

View From Outside Perugia City Walls overlooks a large valley which during the morning was obscured by mist. Cherryl therefore started the day's painting by concentrating on studying the higher ground, painting the valley and distant hills when the atmosphere cleared: 'The plain sky is a useful contrast to the busy landscape but also saved a day or two of my limited time!'

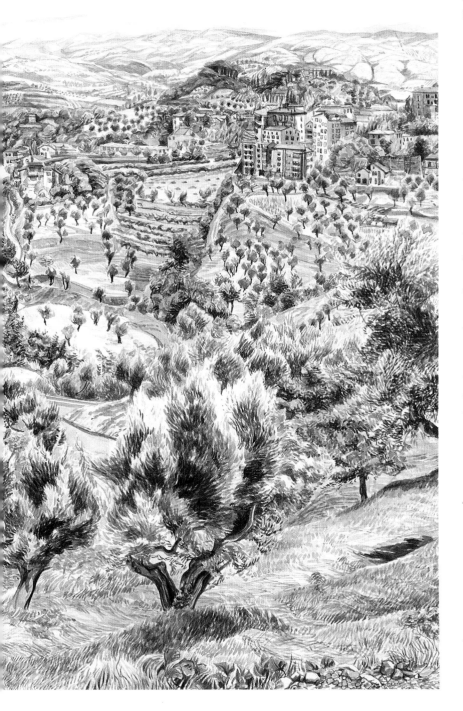

View From Outside Perugia City Walls

420 × 560 mm (16½ × 22 in)
This view takes us from the details of the small stones near Cherryl's perch on the hillside over miles of undulating landscape to the distant Apennine mountains, in only 420 mm (16¼ in) of paper! The neat rows of trees and crops guides the viewer up, down and around the hills and valleys like the contour lines on a map. Winding roads carry you into the distance, the details diminishing and the colours fading as aerial perspective takes over. Control of the relative scale of components in a painting like this requires acute powers of observation, combined with a sure hand. A single stroke of the brush reads as a leaf in the foreground but a whole tree in the distance. A clumsy brush stroke can upset the logic of the whole painting

▲ Sketchbook drawing
290 × 395 mm (11½ × 15¼ in)
*Cherryl likes to draw as often
as possible and her
sketchbooks are full of rapid
pencil drawings made while
visiting foreign places. Here
she has recorded architectural
details and the shapes of local
foliage. A few lines suggest a
face. The beauty of such
sketches is the way they
can suggest more than they
actually describe*

▶ Painting materials
*When working in sketchbooks
Cherryl likes to hold back the
pages with two or three
bulldog clips. In addition to
her range of brushes — small
round sables and a large flat
brush for damping paper —
tissues and a small sponge are
considered essential items, as
well as a water bottle (not
shown). She takes with her
whatever is to hand wherever
she is based*

Cherryl usually works on hot-pressed paper and does not stretch it because she prefers to work to the edge of the sheet and to move the paper around on the board. She likes to start with a large sheet that can be cut down if a certain shape is needed. This depends on the subject and the composition that she works out in sketches. She will often draw a pencil line across the paper where the painting is to stop and then crop it later. Generally she finds that standard paper shapes suit her work, especially those with 'squarer proportions'.

Work starts on the painting itself with faint pencil lines. However, if the subject is very complicated, perhaps with a lot of architectural detail, then a drawing made on another sheet of paper the same size is also used as a guide. Cherryl always begins with the areas that interest her the most, starting with light washes to map in shadows and establish simple shapes. Gradually washes get darker and the painting develops through a series of layers. Colour is built up slowly and she also reworks painted areas by

scratching out, lifting off paint with a small sponge, or adding touches of white gouache. A painting is finished when the paper is covered completely or when time runs out. Only rarely does she work on the landscapes away from the subject, and then only to strengthen a shadow or pick out a point of interest. This is one of the limitations of painting landscapes on the spot; eventually time runs out, it gets dark or she has to go home.

MATERIALS

Cherryl uses a fairly consistent range of colours that she will occasionally supplement. She always has Cadmium Yellow, Cadmium Lemon, Cadmium Red, Alizarin Crimson, Ultramarine and Prussian Blue. To this basic list are added 'treats' such as greens or a colour that catches her eye while buying the others. Cherryl occasionally buys an alternative primary such as Cerulean Blue, or ochres and purples, to mix the colours for specific foliage such as cyclamen. Mixing observed colour is something that Cherryl finds quite easy and often adjusts colours on the painting itself rather than on the palette. When she first painted in

White Garden, Sissinghurst

355 × 330 mm (14 × 13 in)
Sissinghurst is a favourite haunt for Cherryl, and a subject that she has painted many times. She finds the planting in the garden remarkably varied and well planned for colour, texture and weight and also enjoys painting the architectural details that are in the top right of this painting. The watercolour, on smooth paper, took more than a week to complete on site because there was such a profusion of foliage. The bold blocked shapes of the parterre in the centre provide a compositional hub around which the ornate, intricate explosion of foliage revolves

Italy she found the green of the olive trees quite difficult to match and spent a lot of time studying it from specimens taken back to the hotel. Local colour is so important, especially the variations of one hue; for instance, the slight temperature changes in the colour of foliage as the light alters. When studying the ornamental foliage of an English garden like *White Garden, Sissinghurst* (above) the light and colour change constantly. Individual leaves flicker in response to a breeze and cloud shadows can suddenly transform the whole scene.

Because of the intricate brushwork in Cherryl's paintings finding the right brush for the job is important. She uses large inexpensive brushes for broad washes and the best small brushes she can find for finer work. It can be difficult to find a very good small brush. Some have poor points, some are too pointed, and she only really knows whether or not a brush is any good when it has been used for a few days and is

75

All Things Bright
470 × 525 mm (18½ × 20¾ in)
A great deal of time and consideration goes into setting up a still life as complicated as this one. Objects have to be tried in different positions and with different kinds of lighting. Shapes, colours and textures have to be brought together in such a way that they bring the most out of each other whether through contrast or similarity. In this painting Cherryl has placed light objects against darker ones and vice versa. There are busy textures against smooth surfaces, large shapes against groups of small shapes and so on. The painting took about eight to ten days of consistent effort to complete

worn in. Finding the right brush that makes the kind of mark she wants and also holds enough colour can save Cherryl a lot of time as she can cover much more paper in a day with a decent brush. The smooth paper that she uses is chosen because it allows fluid brushwork.

STILL LIFE

Cherryl usually paints still-life watercolours during winter and at night. She has a collection of objects and a

good relationship with both the local museum and the local gunshop, both of whom lend her stuffed birds and animals and other artefacts. A set-up like the one made for *All Things Bright* (opposite) is put together over a period of time, objects moving in or out and changing place until she achieves the result she wants. 'The squirrel was a typical impulse buy and I had to justify the extravagance by painting it in a number of paintings! The shelves were placed behind the still life to create a strong background pattern, but also to fill with personal mementoes. The photograph of Monet keeps a watchful eye over the whole arrangement.' The painting took eight to ten days of consistent effort. It was lit from the side by daylight through the window but with lamps from the same direction at night so that work could continue after sunset. She likes to study the elements very closely, painting the different textures of shells, wood-grain, fur and feathers. Cherryl also likes to experiment with a variety of light sources, such as lamps or candles. Seasonal references, like the blackberries and acorns, along with the squirrel, make one think of a harvest festival and the painting reads as a celebration of nature's abundance. Still-life painting allows Cherryl to explore this kind of imagery as well as exploiting colour and pattern. *From Darjeeling to Dundee* incorporates highly reflec-tive surfaces in which tiny self-portraits can be seen.

From Darjeeling
to Dundee
255 × 330 mm (10 × 13 in)
Cherryl delights in painting
complex watercolours built up
with layers of colour and
intricate brush strokes.
Whether assembling the
components for a still life, or
scrutinizing a landscape, she
has an eye for strong
compositional and colourful
patterns. The highly reflective
surfaces in this arrangement
meant that she could
incorporate the room around
her, and herself, into the
painting, making the most
of the marvellous
distorted reflections

In a sense *Balcony View, Perugia* illustrates what could be described as Cherryl's ideal subject: 'The view had everything – foreground detail, plants, terracotta tiles, reflections and a distant view.' It is a combination of still-life and distant landscape. Objects and edges overlap one another and steer us through the painting, taking us further and further back into the distance. The difference in scale between the close-up cacti and far-off trees was slightly exaggerated to enhance the spatial sensation. Distant objects have to be observed and handled very carefully, measured in comparison to the foreground, because it is easy to pay them too much attention and paint them too large. Although Cherryl, through experience, can spot a good subject like this and knows that it will probably make a good watercolour, she also knows that painting is rarely that predictable: 'You don't always have to know what you want. More often than not you just see what happens on the paper.'

Balcony View, Perugia
420 × 560 mm (16¼ × 22 in)
By chance Cherryl met some people on a train who said that their hotel had a marvellous view, which led her to find this subject. The colours are richer than in many of her Italian paintings because it was painted during wet weather when she could not work outdoors. Masking fluid was used to isolate areas for the pale cactus spines, but Cherryl was unhappy with the initial result and so chose to reverse nature and make the spines dark rather than light

MASTERCLASS
with Lesley Giles

Lesley Giles paints landscapes with watercolour but differs from the other 'landscape' artists in *Watercolour Masterclass* because hers have always been painted almost exclusively inside her studio. She describes her paintings, of actual places, as being 'not naturalistic' but more concerned with creating an emotional, atmospheric recollection. She likes to paint wild open spaces with remote atmospheres and also favours landscapes touched by man, with a blend of rural and industrial heritage. She enjoys the dramatic simple shapes of factory buildings like those in *Factory, Valetta Road* near her home in London. Lesley travels far and wide to locate her subjects and often returns to favourite haunts. She is passionate about these places and finds them so overwhelming that she can only really concentrate by stepping back from them, to paint them from a distance, in the detachment of the studio. She highlights the drama of the landscape, the contrasts of light and shade, the richness of the colours. She observes the landscape and selects just what she needs, employing radical simplification to produce a powerful direct statement as in *Blue Balcony* (overleaf).

Her first watercolours were made as colour sketches for oil paintings while she was an art student. At one tutorial it was pointed out how good her watercolours were in terms of colour by comparison with the oil paintings! This made quite an impression and from then on watercolour became a more important medium for her.

Factory, Valetta Road

330 × 510 mm (13 × 20 in)
Lesley likes to paint a variety of landscape subjects which range from the industrial view from her studio window in London to places of outstanding 'natural' beauty around the world. In this view from her studio she was inspired by strong autumnal light casting long shadows across the stark shapes of factory buildings. She has simplified the shapes and intensified the chiaroscuro to heighten the dramatic stormy atmosphere. Composing with large simple shapes provides the opportunity to place large areas of colour side by side for maximum effect. Lesley invented the pale orange forecourt and the strong crimson of the shadow to reflect the time of year, and charge the atmosphere with emotional tension. This expressive handling of colour is typical of her approach

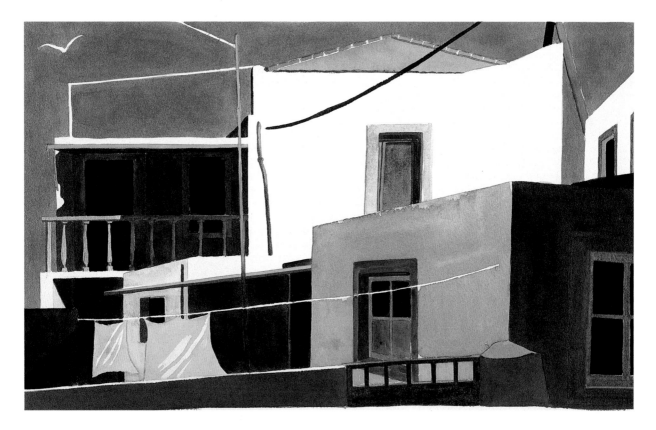

Blue Balcony

305 × 480 mm (12 × 19 in)
*In this painting the first colour
to be applied was pale blue to
isolate the striking white shape
of the sunlit building. As the
painting developed the blue
sky was enriched with further
washes of blue, producing a
vibrant background to 'set off'
the complementary orange roof
and bright white areas of
paper. Further layers of
Indigo, Viridian and Alizarin
Crimson were built up to
create deep colourful shadows
against which the pure yellow
washing hangs. Lesley also
exploits the juxtaposition
of light against dark and
dark against light in this
skilful composition, making
the most of thin linear
elements criss-crossing the
solid geometric forms of
the buildings*

MATERIALS AND PREPARATION

Lesley's first materials were a gift, a small watercolour box which she still uses many years later. Another box was acquired with the intention of extending the range of colours but she found that this did not help her, and that her preference was for a simple palette. Her paintings are done using the simple range of materials seen in the photograph opposite. She finds that a palette of Terre Verte, Indigo, Cerulean Blue, Burnt Umber, Yellow Ochre, Alizarin Crimson and sometimes Gamboge caters for all her needs. She avoids using black because she feels it 'kills' colour mixes and she dislikes the qualities of Ultramarine or any bright greens. Her theory is based on personal preference. The watercolours that she uses are the same brand as her oil paints and share consistent colour qualities. This makes life a lot easier for her

because when changing medium she does not have to refamiliarize herself with a different selection of colours that would behave in a totally different way.

She chooses paper with a rough surface and usually works on one with a weight of 180 g/m² (90 lb). One particular paper had an appealing surface but when wet Lesley found its smell unpleasant, so she stopped using it. She always buys the same-sized sheets and sticks to a standard proportion when dividing the sheet into smaller portions, halving or quartering it. The paper is soaked in a sink of water for a couple of minutes and while it is soaking Lesley cuts strips of gummed paper tape with which she will tape it down. A large sheet is fitted into the sink by folding it one way and soaking, and then folding it the other way and soaking again. She has a number of drawing boards of sizes suited to the usual format of the

paper and when stretching paper prepares a few sheets at a time. This is essential because when she paints she has to wait for washes to dry so usually paints more than one picture at a time. Once drained and taped down, the paper is left to dry and stretch for about twenty-four hours before it is used. Lesley used to stretch heavier weight papers but found that during hot weather they would dry very rapidly and shrink so violently that they would tear or pull free of the tape.

LOCATION REFERENCES

Lesley rarely paints outside and dislikes trying to brave the elements. She has extremely sensitive eyes and has to wear sunglasses when working outdoors. She draws and paints her subject from a van, set up with a table and a comfortable seat. Drawings are made with coloured pencils and are the most important means of recording the view – the watercolours that she will paint when back at the studio are based closely on these drawings. Lesley paints small watercolour sketches in the van, but never uses these for direct reference when painting a studio watercolour, though they might be used as a source for work in oil pastel or oil paint. This is because she finds it boring to paint a second version of a sketch with the same medium. It is more exciting and demands more innovation to base an oil painting on a watercolour, and therefore produces a better end result.

Watercolours painted in the van usually take about twenty to thirty minutes and follow an observation period of about the same time. Lesley tries to 'absorb' the local colour by not only making specific studies but by constant study throughout a journey. It is usually a particular light condition or colour combination that will catch her eye and make her stop to draw or paint.

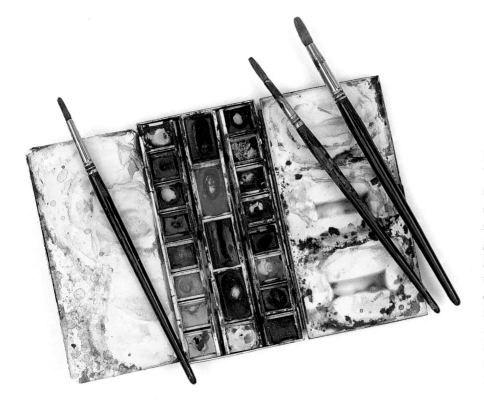

Paintbox and brushes
This Spartan equipment is all that Lesley needs to paint her watercolours. She likes the simplicity of working with a pocket-sized paintbox and just three brushes. Her watercolours rarely feature any calligraphic brush strokes so she finds that this trio of round sables are ideal for blocking in either small shapes or large areas of layered colour

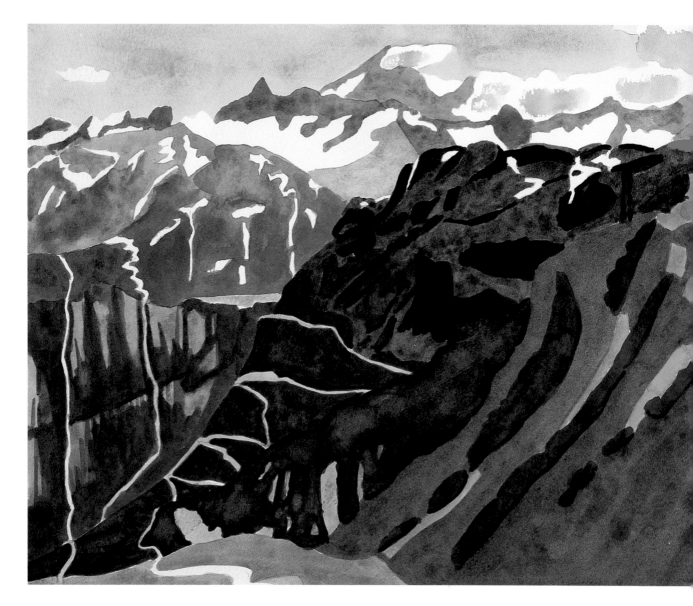

Rhône Glacier 1990
305 × 510 mm (12 × 20 in)
Lesley painted this watercolour
in her studio from coloured
pencil drawings made in
Switzerland. Two of the
many drawings she made can
be seen opposite and are
typical examples of the method
that she uses to collect ideas
for watercolours while
travelling. The drawing of the
glacier was made in response
to seeing it appear as a small
blue shape in the middle
distance of a vast
mountainous expanse.
Coloured pencils were used to
record the patchwork of
shapes, working out the white
areas that are left as
unpainted paper in the
watercolour. The sketch also
recorded the greyness of the
distant mountains and the
brighter colours of the closer
foreground slopes. Back at the
studio this aerial perspective
was exaggerated to improve
the sense of great distance.
The pale blue of the sky was
painted first and then the
greyer tones of the background
mountains and the pale greens
of the foreground. The richer
greens of the closer slopes were
built up in layers around
islands of white paper which
were then washed in with
ochre. Lastly, the warmer
brown tones were painted. The
layers of colour are built up
with a slight variation of
colour density. This creates a
softer velvety texture, less
stark than the flat washes in a
watercolour such as Blue
Balcony on page 82

▲ Coloured pencil
drawing, Rhône Glacier
215 × 300 mm $\left(8\frac{1}{2} \times 11\frac{3}{4} \text{ in}\right)$
*Coloured pencils on smooth
sketchbook paper*

▼ Coloured pencil
drawing, Ticino
215 × 300 mm $\left(8\frac{1}{2} \times 11\frac{3}{4} \text{ in}\right)$
*Coloured pencils on smooth
sketchbook paper*

A studio watercolour such as *Rhône Glacier 1990* is based upon a coloured-pencil drawing made on location. The drawing of the Rhône Glacier is shown here along with another typical sketch made in Ticino during the same journey. These sketches record the basic composition of the painting, establishing proportions, the position of the horizon and major points of interest. They also provide a source of reference for local colours and the tonal structure, usually simplified into alternating

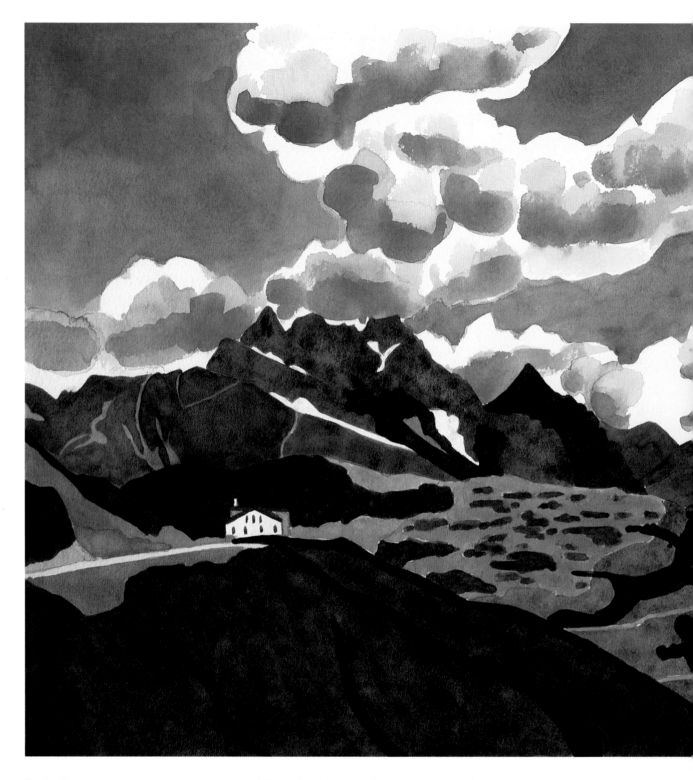

Furka Pass

330 × 510 mm (13 × 20 in)
Lesley also based this
watercolour on coloured pencil
drawings and photographs
from a journey through the
mountains of Switzerland.
The painting was inspired by
the jagged mountain peaks set
against unusual patterns of
white clouds. The slopes come
together like interlocking
fingers, creating overlapping
blocks of strong colour that
recede into the distance. The
white hotel perched against a
dark background provides a
dramatic sense of scale

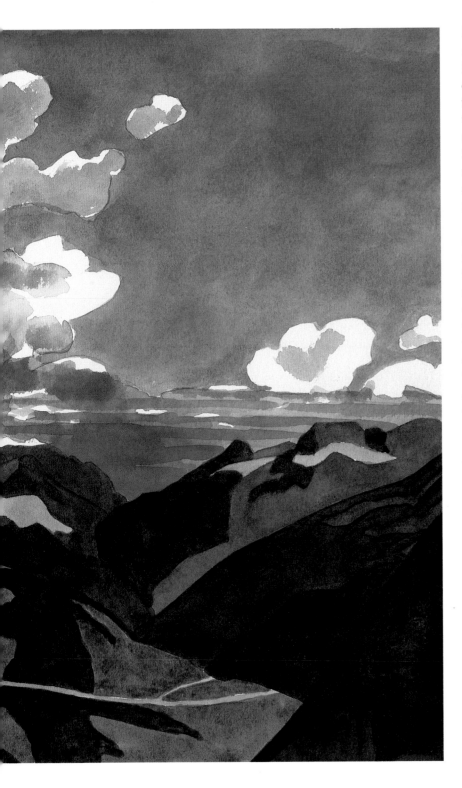

layers of light and dark contrasts: 'I re-create an artificial space and invent colour combinations that best express the subject.' Lesley studied the theory of perspective while she was a student and automatically applies this in practice in her work. She uses her 'eye' to determine perspective and may exaggerate certain elements to make the composition more forceful.

Lesley may also take photographs of the view which are useful for remembering details if she needs them. From these studies she will subsequently sketch out the basic composition on the stretched paper with an HB pencil, concentrating on the composition and the specific qualities of shape, just using line. This drawing is usually fairly detailed, but totally functional, and will be completely obliterated when covered with watercolour. While she is drawing Lesley is always thinking carefully about 'the very important' areas of the composition which are to be left unpainted and therefore white.

PAINTING METHODS

Lesley's procedure is methodical and consistent. She paints with the board flat on a table and sits while working. Colours are applied by starting with the lightest and finishing with the darkest: 'I break down the subject into shapes and then block in the colour.' The first washes of colour are normally in the region of the painting's horizon, perhaps the sky. Many paintings feature cloudscapes, such as *Furka Pass* (left). Here it was essential to isolate straightaway those parts of the clouds that were to be white, so a pale sky tone was put down first. The whole painting was then

developed layer by layer, trying to build up the picture as a whole. Each layer of watercolour is allowed to dry before the next is added, so while it is drying Lesley will start another painting. This can evolve into a series of three or four paintings, all exploring the same subject. Sometimes a series of related paintings might be interrupted by a sudden need to capture a thought relating to another theme. Lesley always tries to remain open to such impulses, allowing them to feed into and enrich all the paintings.

The process of layering averages around three or four stages but this is not predetermined and never restrictive. Some paintings need more, some less. If a painting starts to go wrong or begins to look too heavily worked or laboured Lesley washes the paint off it with a large brush, lets it dry and then takes it up again later. She only ever uses two or three small sables and blots excess colour off the paintings with tissue.

Early watercolours also combined ink drawing, partly because she feels that she was not fully confident with handling fluid paint. Now that her techniques and confidence have developed Lesley uses just paint and can work without any 'props' such as masking fluid. She never reworks the white areas of her paintings by adding gouache or Chinese White. If a painting goes wrong in terms of these areas of white paper it cannot be corrected and is therefore discarded. Lesley used to throw a lot of her paintings away!

FINISHING OFF

Watercolours are left around the studio walls for anything up to a couple of months so that Lesley can study them and decide whether or not they

Back Alley

330 × 510 mm (13 × 20 in)
Colourful autumn light fills this watercolour sunset. The windows of the building in the background mirror the yellow of the sky and the chimney stacks are illuminated with strong orange reflected light. The back-lit trees stand out against the shadows behind them. The windows of the houses mirror a different part of the sky, a cool blue which is made even cooler by the contrasting orange brickwork surrounding it. Right at the centre of the painting the white paper is left unpainted to provide the brightest light. Wet-into-wet washes were used for the sky, allowing a crimson and a blue wash to bleed together. The foreground trees were left as white paper until the final stages of the painting when they were washed in with Yellow Ochre

are finished, or worth keeping. Because they are painted on a table in a horizontal position she is not sure when painting exactly what a watercolour will look like when viewed upright against a wall. With oil paintings painted vertically on an easel the image develops in the same plane in which it will be viewed later. With watercolours, however, it can be a shock to lift up the painting from the table and find that it looks completely different.

A watercolour is 'finished' by experience. The paper can only absorb a certain amount and her watercolours are rarely sustained for the length of time that an oil painting might be. Lesley believes watercolour is fundamentally more immediate and quicker to use and asks: 'Why re-work or overwork when you can simply paint another?'

MASTERCLASS
with Charles Reid

Charles Reid has painted both with watercolour and with oil paint for many years. He has also written a number of books and made several videos about painting with both mediums. In fact it was one of his early books, *Portrait Painting in Watercolour* (Watson-Guptill, New York, 1973), that spurred on my own early attempts at painting, so it is a special pleasure for me to write about his work in *Watercolour Masterclass*.

Charles has always painted watercolours of a wide range of different subjects, working both indoors and outdoors and including flowers, landscape, still-life, animals and figures. His figures appear in varied settings too, such as the art school life-room or studio, a domestic interior or an outdoor environment. There is an informality in his watercolours; this is seen especially in his portraits, which form such a rich element in his work with the figure. Whatever his subject Charles always strives to paint it in a simple and direct manner, taking advantage of the natural behaviour and characteristics of the paint – 'letting the watercolour do the work on its own'.

His watercolours are characterized by a dynamic and expressive handling of the paint, sometimes combined with flowing pencil lines. All artists' work changes with time and Charles believes that his own painting is now becoming more and more concerned with exploiting colour, and less with tonal composition, which was a hallmark of his earlier paintings.

▶ Life-class Painting
510 × 405 mm (20 × 16 in)
Here, a rapid and confident flowing line is used to delineate the figures in different poses. There is no time for reworking or correcting line and wash paintings like these. The colour is applied to record shadows and define forms, and although the colours are delicate the washes are painted boldly

Stephanie
Bidery Club-

PAINTING MATERIALS

Most of the watercolours that Charles paints are done away from the studio – in his kitchen, at a life class or outdoors, for instance. His studio is utilized mainly for oil painting. However, no matter where he is painting with watercolour the equipment used is nearly always the same: a portable easel, a metal mixing palette and paints, paper, brushes, a pencil and paper tissues. He does not use inks or acrylic paint and has a total aversion to masking fluid, which he describes as a 'murderous substance'. He buys good-quality artists' grade watercolours in pans and tubes, only avoiding those in tubes that are too watery, because they tend to mess up his bag.

Charles has no organized method of approach apart from setting out colours on his palette. Here he considers some system of arranging warm, cool and earth colours essential and advises his students to put out all their colours, not just those that they think they might use during a painting session. A typical arrangement can be seen in the photograph above but at the end of the day it is really a question of personal preference, 'as long as you know where they are, that's what matters.'

COLOURS

The same range of unmixed colours are the starting point for all subjects, though with some modifications. For example, if painting figures he uses a warm yellow such as Cadmium Yellow rather than a cold one such as Lemon Yellow. The only blue he uses for skin tones is Cerulean, though he will use Ultramarine and Cobalt Blue in other parts of a figure painting or for other subjects. He

never uses Payne's Grey, Davy's Grey or Sepia and only rarely uses greens, preferring to mix them from primaries or from yellow, such as Yellow Ochre and Ivory Black. Of available greens, however, he finds Hooker's Dark, Viridian and Sap the most versatile.

In mixing colours, especially for skin tones, Charles avoids overmixing on the palette, but lets the individual ingredients blend together on the paper. This creates subtle nuances of hue and tone in the mixture, keeping colours fresh and vibrant. It is here that Charles reveals his understanding of the nature of watercolour most fully – how to allow it to bleed and run around on the paper but under his guidance. In *Kitchen Still Life* you can see this method in action in the shadows. The orange paint bleeds from the orange fruit into its blue shadow, and other shadows throughout the painting are full of colour modulations.

◄ Palette and layout of colours
This shows a typical layout of Charles's colours in a metal folding palette known as a 'Holbein'. He places his colours in families of cool and warm hues, followed by earth colours, one green and black. There is also a tonal structure to this layout, the hues arranged from dark to light in the cool and warm sections (travelling clockwise) and from light to dark in the earth colours

► Kitchen Still Life
*760 × 560 mm (30 × 22 in)
Casual objects and an informal arrangement are what Charles looks for in a still-life subject. Cast shadows are used to tie objects to their surroundings. The glass vase and blue and white vessel at the back of the arrangement are positive shapes established by painting the negative shapes that surround them. Drips were allowed to run down the painting but the two on the left were blended into the pale washes on the table top. The drip of colour on the right seems to stress the plane of the table top and carry the viewer's eye up from the bottom edge of the paper into the depth of the painting. Drips like this have a fascinating split personality: they affirm the flatness of the picture plane and the paper itself, and yet simultaneously guide us into the illusion of three dimensions*

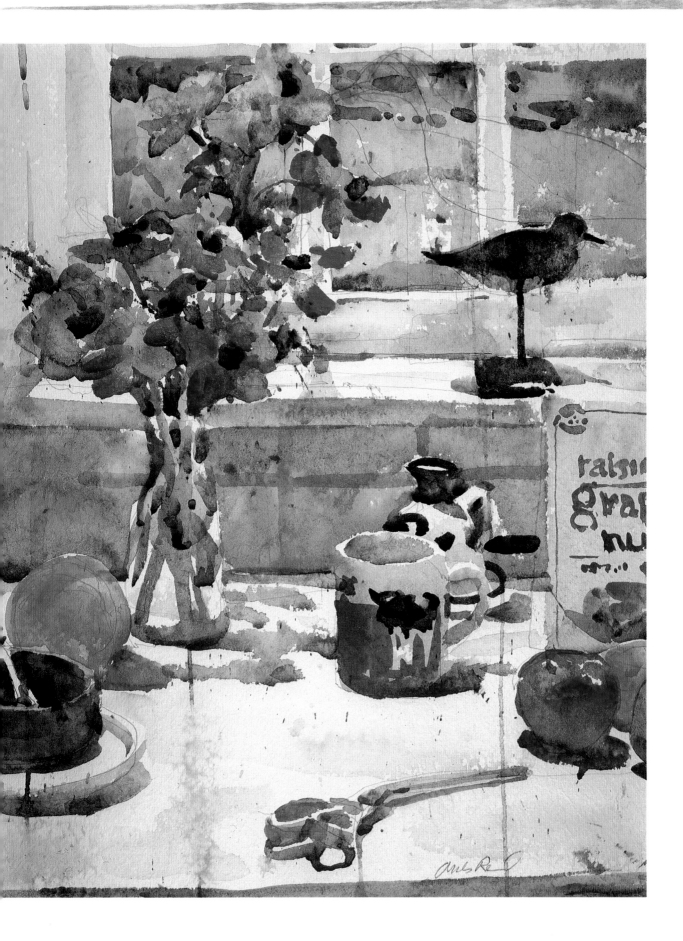

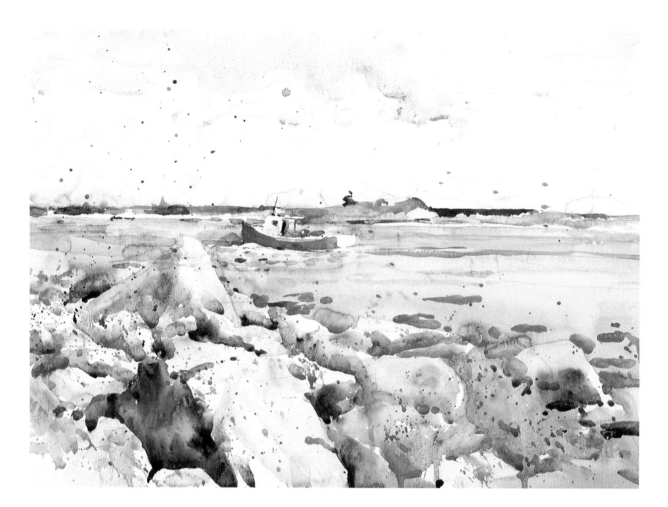

Lobster Boat

455 × 610 mm (18 × 24 in)
This breezy outdoor
watercolour was painted in
strong sunlight. Both the tonal
range and colour range are
kept to a minimum. Charles
encourages his students to
avoid the trap of painting to a
formula, and here he breaks
the common convention of
aerial perspective, placing the
darkest tone of the whole
painting, a deep Ultramarine
Blue, at the far distant horizon

Gouache, Chinese White or just thick undiluted tube watercolour are sometimes added to correct or edit out unwanted marks. Charles is not concerned at all with colour theory, though he admires the work of artists like Seurat and Signac and their explorations of optical colour mixing. His ideas about colour stem from his own painting and from looking at the work of Gauguin, Vuillard and particularly Bonnard, who juxtaposes warm and cool contrasts throughout a painting. Charles's early watercolours were more concerned with edge control and tonal values than colour, but colour is now much more important to him.

PAPER AND BRUSHES

Charles paints only on white paper and chooses a medium (cold-pressed) or a rough surface, favouring a weight of 300 g/m² (140 lb) whatever the brand. He does not like heavily sized non-absorbent paper. Since he does not soak or pre-stretch paper, he finds that non-absorbent brands repel washes too severely. When working on individual sheets of paper he simply attaches them to a thin board with bulldog clips. Charles also paints on watercolour blocks and in sketchbooks and, in the case of the latter, prefers hardbound books as he feels that they add an air of importance to the work going into them.

He considers his brushes as 'treasured items' especially his collection

of large round Kolinsky sables, though he takes just as much care of his 'excellent' synthetic brushes too. Charles also believes that it is not only how you treat brushes when you have finished painting that is important, but how you actually paint with them. He never brushes paint across the paper with the tip of the brush, but uses the belly and heel. Pressure is applied to keep the tip clear of the paper, which is easier if you use the largest brush you possibly can. This keeps the tip in good pointed condition when needed for fine control of intricate shapes.

After painting, Charles always washes brushes in mild soap and water and never stores them away wet. If travelling he places them in a brush tube, but will lay them out when he gets home to dry thoroughly.

Baccaro Rocker
510 × 510 mm (20 × 20 in)
The choice of white paper and the amount that is left blank fill this watercolour with light. Brush strokes move in different directions and create a great variety of marks, especially in the flowers where no two shapes are the same

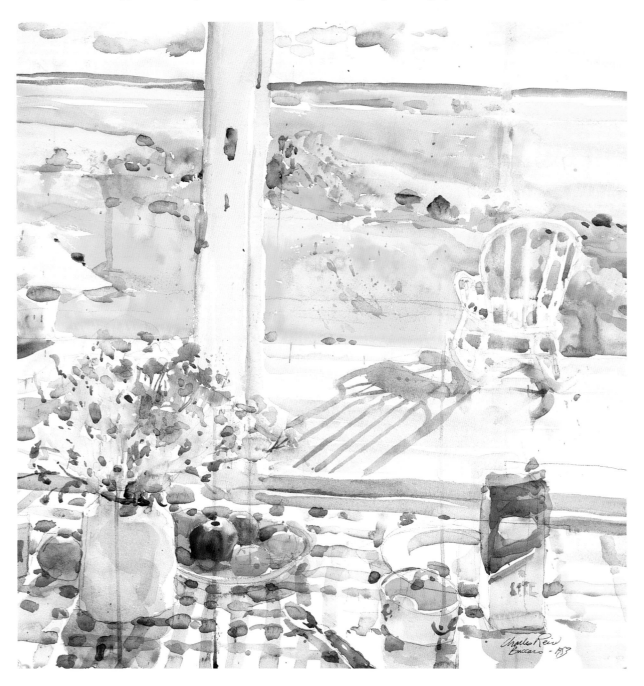

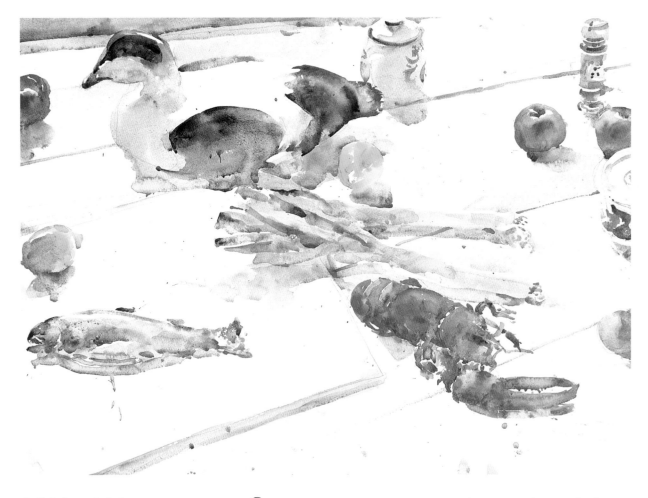

Still Life with Lobster

560 × 760 mm (22 × 30 in)
*The idea in this painting was
to use colour right to the
borders of the painting, to
make the entire sheet of paper
interesting. The high viewpoint
seems to tip up the table top,
with the back edge raised close
to the top of the paper. There
is no single point of focus in
the painting. The strong
colour of the lobster attracts
the viewer's attention but the
eye soon wanders off. You
tend to follow the claw to the
right and then track up the
edge of the painting and
around in an anti-clockwise
spiral, finishing up back
towards the centre at the tail
of the fish*

COMPOSITION

In his books on painting with water-
colour Charles often encourages
readers to make tonal and composi-
tional preliminary studies, perhaps
with a pencil. He views these as
valuable learning exercises and as a
method of practising observation,
but he does not use them in relation
to his own watercolours: 'I work
very directly and if I make a mistake
I start again.' Charles believes that
whatever you can glean from a small
pencil preliminary sketch it is impos-
sible to figure out exactly what will
work on the final scale of the paint-
ing. A purely tonal study will not
relate to the effect that colour will
have on a composition, even if you
resolve the general areas of light and
shadow. Eventually you are compos-

ing with pure colour, which can
completely alter the best-laid tonal
plans: 'The main thing is just to
keep squinting and get the big idea
of the picture.'

Charles does not really like the
idea of over-careful composition,
either in the painting itself or in
terms of arranging the elements for a
still life, preferring to 'organize the
chaos of scattered objects'. Paintings
such as *Still Life with Lobster* avoid
any single point of focus, the eye
being guided almost haphazardly
around the whole of the painting,
even including the periphery. This is
also the case in *Double Portrait*,
where the strong dab of red on the
lower-left edge of the sheet pulls the
eye out of the centre of the painting,
preventing it from focusing only on
the figures' faces.

Double Portrait

560 × 760 mm (22 × 30 in)
This portrait was painted as a demonstration for students to show how to design the entire sheet of paper, and not always to focus directly on the subject. The figures look in different directions and not towards the viewer, creating an informal atmosphere. The pose was a difficult one because the leg of the man produced a very awkward shape. However, just because a shape is there in the subject does not mean it has to feature in the painting. Here this was dealt with by 'losing' the underside of the leg, letting it blend and disappear into the white of the paper. It is a form of orchestration. Charles knows how to fine-tune the balance between one element of the painting and another

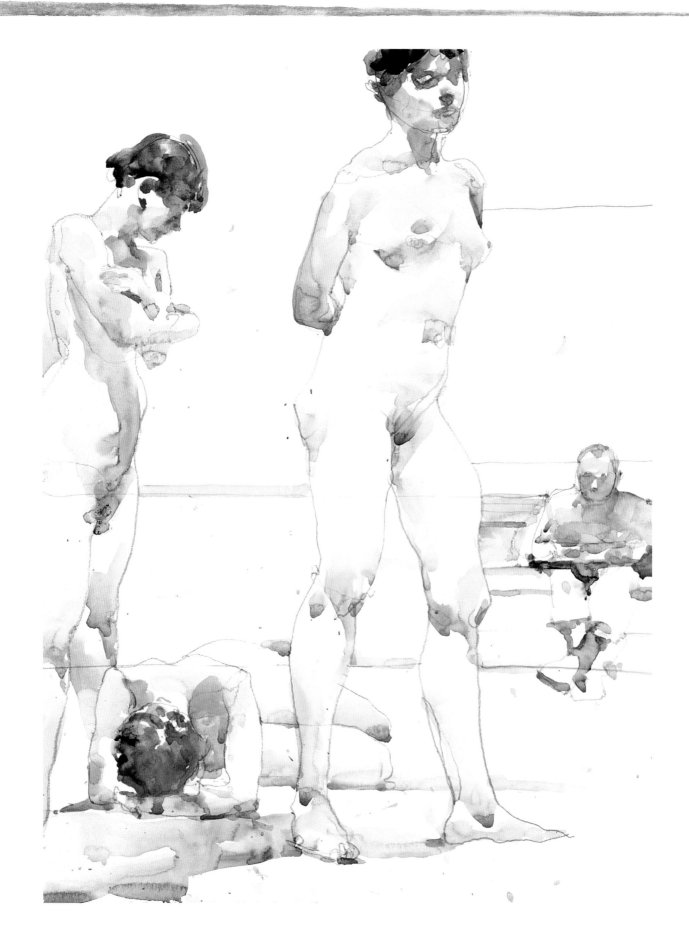

▶ Life-class Painting

405 × 510 mm (16 × 20 in)
This relaxed study shows a
female nude in two positions,
seated and reclining. Painting
such a complex subject with
such simplicity requires clarity
of observation and a good
notion of what to leave out.
Charles never feels trapped by
reality. The figures must be
simplified to their most basic
forms and to unified areas of
light and shadow. Charles's
notion of pictorial composition
is to lead the eye through and
around the painting. He likes
to attach figures to the border
of the paper rather than isolate
them in the centre. Here, this is
done by the arm of the
reclining woman going out of
the painting, as does the head
of the seated figure. The eye of
the viewer follows the multiple
directions of the forms placed
along a diagonal axis and
travels outwards from this to
the periphery of the picture

◀ Life-class Painting

510 × 405 mm (20 × 16 in)
When sketching with line and
wash, as here, clean water is
used to adjust the hard and
soft edges of washes in crucial
areas or to run washes
together. It is important that
paint on the palette is kept
moist so that it can be picked
up quickly when it is needed

PAINTING FIGURES

Charles believes that skilful observation is at the root of successful figure painting. Thus he teaches his students that there are really no more problems in painting figures than in painting any other subject; it is primarily a question of learning to simplify the figure into basic shapes and forms, painting the total pattern of light and shadow right across anatomical boundaries. The *Life-class Paintings* (opposite and above) show how he uses a combination of pencil line and broad washes to do this. In the painting with three women the same model was asked to take up three poses, each for about twenty minutes. Charles then painted each pose, bringing them together in one image. This is the type of exercise that he really enjoys, though it can easily fail if one sketch goes wrong, ruining the effect of the other successful ones.

It is easier to simplify a figure if a single light source is used that will cast descriptive planes of light and shade and defined shadows across the body to delineate the contour of the form. In the *Life-class Painting* on page 90 this can be seen clearly in the cast shadow on the upper thigh which describes the curvature of the form between the outlines. In rapid paintings like this everything must be stated clearly and with simplicity, avoiding too much study of separate parts of the anatomy. Pools of light and shadow run together to make larger shapes, irrespective of physical borders. This is the case with the shadow that integrates the leading edge of the left arm of the standing figure with the left side of her torso and hips.

PAINTING PORTRAITS

Painting portraits, especially of close friends, can be very demanding. If you are painting a tree, for example, and you alter the position of a branch by a few centimetres, nobody notices. In a portrait the tiniest change of position of any feature in relation to the others can change a person's appearance. As Charles has pointed out in his own books this can result in artists

'tightening-up' and scrutinizing individual features too severely. This produces the opposite of the 'good likeness' that is required, as the features seem to separate from each other and from the overall form of the head, creating a stark, fragmented description of the face.

It is far better to concentrate on the areas of light and shadow and how these mass together across individual features. The lips in *Girl in Black* illustrate this point. The lower lip blurs into shadows around it, establishing a connection with the rest of the face. Similarly, shadows on the cheeks do not stop at the edge of the nose but travel across it.

▲ Redhead, White Hat
560 × 760 mm (22 × 30 in)
It is essential in a portrait to mass shadows together, even pale and luminous ones. In this painting the hair is not treated as separate from the shadow of the face but joins with it. Charles would only stop painting at a boundary like this if the hair was clearly a lot paler than the flesh. Decisions made during the initial pencil drawing are often adjusted as the painting develops. For instance, the edge of the throat was redefined by a darker wash overlapping the original pencil line

▶ Girl in Black
760 × 560 mm (30 × 22 in)
The tones of the woman's hair and clothing were made paler than they actually were to prevent such expanses of black 'popping' out of the paper. Charles often adds some Burnt Sienna or Ultramarine to Ivory Black to give it an interesting variety of depth. He likes to make use of what he calls 'escape routes', breaks in the shadow and edges that allow the viewer's eye to travel in a different direction. The silhouette of the hair is full of variety, crisp on the left, but blending into the cast shadow on the right, with lots of breaks in between

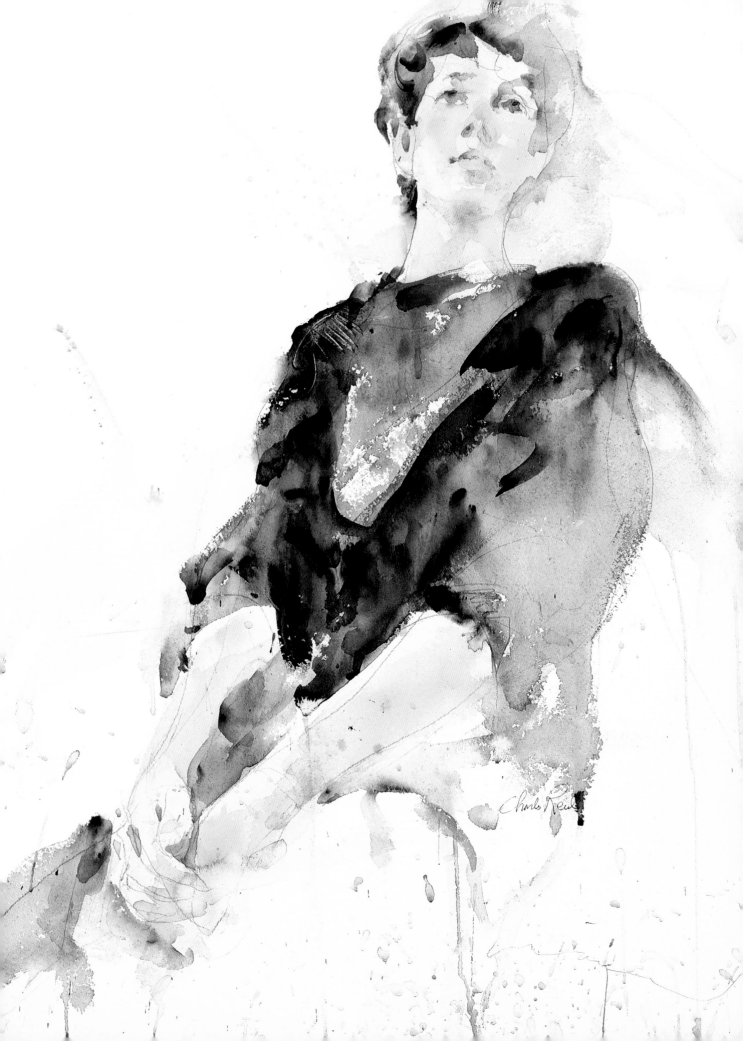

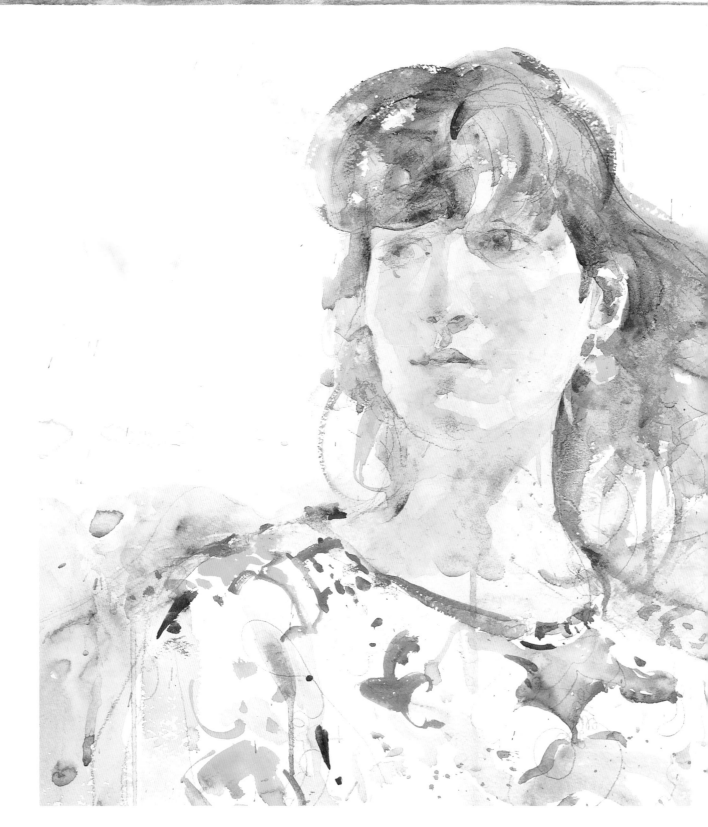

In *Karen II* a subtle natural light falls on to both sides of the face, the stronger light on the right side of the painting also cutting across Karen's neck. Charles started this portrait by brushing in the palest flesh tones first, painting right over the boundary of the hair and face and across

first washes were also extended right out of the face into the background where he then modified their colour, cooling down the area of the wash in the background.

Once these initial washes were dry a mid-tone was added, concentrating on areas where specific shapes and contrasts needed to be stated, as on the nose or the neck shadow, and the eye sockets: 'The shapes and edges of these washes are critical and have to be right, whatever the colour.' Next, the edges of these washes beneath the eye socket were softened by adding water, and the colour of the nose and the whole centre line of the face was strengthened. Charles worked down the centre, keeping the brush on the paper, keeping the washes moving, working across the mouth and not around it. The mouth has harder edges against the light but softer, less specific, edges in the shadows. The darker, cooler shadow beneath the lower lip was a crucial feature to establish the form of the lips in general. Washes continue down across the chin, breaking the edge of it and travelling down into the neck. Notice the subtle paler patch of reflected light, the initial wash, left exposed to create both a sense of reflected light and the third dimension.

Karen II epitomizes Charles's approach to watercolour. The first exploratory washes and speculative marks are visible side by side against final demonstrative washes. The viewer's eye is led through the painting by a brush that has been moved in different directions and as we follow its path so we explore different facets of the subject. There is freshness and spontaneity, evidence of sheer pleasure in watching watercolours puddle and drip over the whole sheet of paper.

the eyes, nose and mouth. He never leaves strong white shapes for the eyes or mouth and only the dress was left white at this stage. These

Karen II
560 × 760 mm (22 × 30 in)
Charles always aims at achieving a total harmony between the figure, the clothing and the background. Light, shadow, lines, washes and colours interconnect throughout the whole painting. The brush is moved in multiple directions, in a variety of movements. Boundaries come and go, and the viewer's eye is free to move around the whole painting

MASTERCLASS
with Paul Riley

As a child Paul Riley remembers finding an affinity between oil paint and the glittery surface of a model aeroplane he was painting. The paint was perfectly suited to the subject. After twenty years of painting almost exclusively with oils he moved house from the city to the countryside. Here, amidst 'billions of leaves and flowers', he discovered that watercolour had an affinity with his new environment. It was perfectly suited to nature's colourful exuberance.

Flowers epitomize this exuberance and reveal nature's energy in all her splendour. For Paul, painting them in the studio is like bringing a slice of nature indoors. They are exciting to paint because they are so full of fluid shapes and colour and are rich with abstract potential. He also sees flowers as having strong individual personalities, like the 'aggressive' *Giant Pink Poppy* overleaf. With watercolour he can create intensity of colour and yet retain a sense of the flower's physical delicacy. Watercolour is ideal for capturing the effects of light, such as very strong light shining through a translucent petal, reflected colour, or the interplay of light and luminous shadows in a still-life grouping.

As colour is so important in flower painting Paul uses a great diversity of watercolours. It is not only hue that has to be considered, but also other qualities such as transparency and colour intensity. Flower petals exhibit a wide range of subtle qualities and some brands of paint are more suitable than others for expressing these differences.

Daisies with Red Peppers
560 × 760 mm (22 × 30 in)
For Paul a flower subject like this provides a wonderful array of interconnections between shapes and colours, and some areas of completely abstract potential. Pure colour, pattern and form can be explored for its own sake. Choosing the right viewpoint can transform the ordinary into the unexpected, so the subject was studied from all angles to find the most exciting one. Certain areas of this painting required meticulous observation and treatment, such as the negative shapes that Paul painted around the daisies themselves to create their white petals

Giant Pink Poppy

560 × 760 mm (22 × 30 in)
Paul describes this
watercolour as a painting
showing the aggressive
strength inherent in some
flowers. He also sees them as
having a dual personality —
delicate and attractive to
insects, yet predatory to other
plants with whom they
compete for space in the
landscape. The daisy on the
left of this painting is painted
like a target for insects to
home in on. So, there is a lot
more to flowers as a subject
than simply their appearance!

PAINT AND COLOUR

Paul finds that the most expensive paints are not always the best for his purposes. For example, he prefers one 'student' grade Lemon Yellow to any other because it has a transparency ideally suited to painting delicate petals. Some flowers have such a high chroma that a paint made with extremely pure and finely ground pigments of the best quality is essential. This is often the case with red flowers and the best red paints are usually expensive.

He uses very few earth colours and no black, preferring to have a range of intense primary colours on his palette, from which he can mix secondary and tertiary hues. He occasionally uses a range of greens. The other characteristics of watercolour are as important as its colour qualities. He prefers paints that colour by staining to those that precipitate, and rarely uses Ultramarine in colour mixes simply because it precipitates, seeming to make colours muddy.

Paul actually manipulates the way that some paints do not mix together properly when he is painting flower stalks. One colour is painted down, left wet, and then another placed into it, forcing the first colour to the edges of the wet brush mark and creating an illusion of roundness.

BRUSHES

Paul loves paintbrushes and has a large collection, as can be seen in the photograph. Each brush is carefully suited to a particular task or favoured because it makes a certain mark. *Yellow Roses* was painted solely with a large oriental brush. Many of Paul's paintings are composed of a plethora of specks and strokes, combining pointillist touches with broad oriental sweeps.

◀ Paintbrushes
Paul uses a wide range of paintbrushes. His favourites include squirrel-hair, sable and oriental brushes

▼ Yellow Roses
280 × 380 mm (11 × 15 in)
This rapid sketch was done with a large oriental brush, making the most of slashing, gestural brush strokes. The silhouette of the rose on the left was established by painting a dark green wash around it. This wash obscures some earlier, paler washes, restating the flower's edge. Paul likes to employ this form of bold editing as a painting develops. The shape must be defined with great confidence, and Paul has resisted any temptation to fiddle with it afterwards

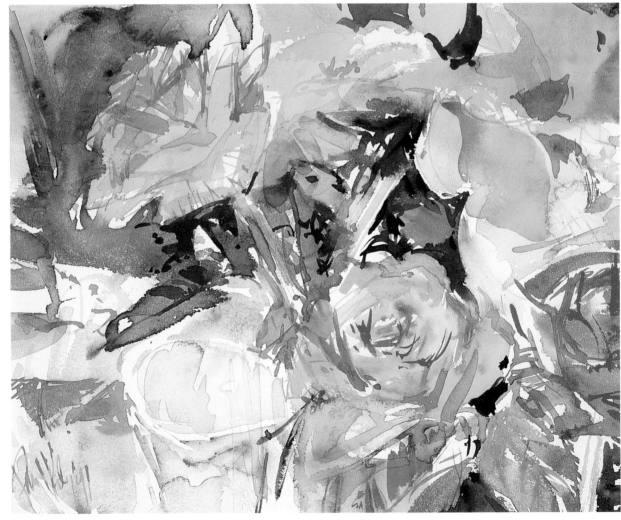

107

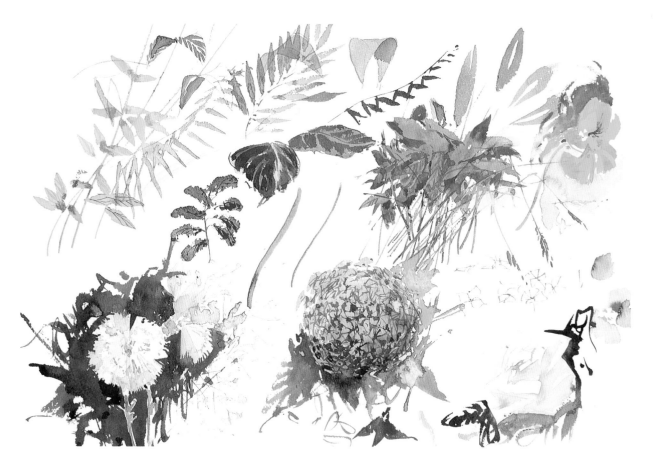

Plant Exercises

380 × 560 mm (15 × 22 in)
This step-by-step guide was
done to demonstrate some of
the ways in which you can
paint leaves. It features
various techniques that explore
expressive handling of the
brush. Leaves may be
represented or suggested with
single touches of the brush in
an oriental style, or delineated
with a fine line using the point
of the brush and then washed
in with the brush on its side.
As in many of his paintings
Paul also shows how you can
define a leaf, or any shape in
fact, by painting the negative
shape that surrounds it

Plant Exercises is a sheet of studies painted to demonstrate the types of marks that can be made with a variety of brushes, and how these can be applied to paint the leaves of various flowers. Because brushes are so vital to his method of painting Paul takes great care of them. They are never left in a jar of water during use, but are simply rinsed out and laid flat on the table. He has an ingenious method of carrying brushes around safely by wrapping them inside bamboo place-mats to protect both hairs and handles.

PAPER

Paul uses a variety of good-quality watercolour papers and also very absorbent printmaking papers, which he describes as almost like painting on blotting paper. One piece of advice he gives in relation to using such paper is to handle it with great care. Grease from the hand penetrates the paper easily and is invisible until you wash some paint across it, resulting in blotches. Though his paper is handled and stored with methodical care it is never treated like a precious substance; he feels that if you worry about spoiling the paper before starting to paint then you have already failed. Paul recommends keeping a stock of paper so that there is always another sheet handy: 'It's an overhead that has to be accepted or your paintings suffer.'

He does not stretch his paper, which is normally quite heavy (300 g/m^2, 140 lb), but fastens down each corner with masking tape. If he is painting outside he uses a light-weight sketching easel and a board, customized to hold the paper with bulldog clips, two palettes and a water pot.

GETTING READY

Paul takes preparation very seriously and spends a long time getting everything ready, including supplies of cigarettes and a flask of coffee. Once he starts painting he works very intensively and any disturbance can be disastrous. Everything must be close to hand. He places his most widely used brushes together and then sorts out other groups of brushes for specific tasks, fanning them out on the table around him.

Plastic palettes with deep pans that will hold large quantities of watercolour are laid out in groups too. There might be up to six, each containing a range of similar primary hues. Some regularly mixed hues such as yellow and blue might be placed in the same palette, but Paul is scrupulous in avoiding contamination of individual primary colours. This whole ritual is part of an essential process of 'psyching up', preparing both materials and mind.

Painting table in the studio
In the foreground of this photograph you can see the collection of palettes that Paul mixes his colours in. His energetic, spontaneous style is founded on methodical preparation which always ensures that diluted colours are kept clean and instantly accessible

SETTING UP THE SUBJECT

For Paul, painting is a form of orchestration and, like musical composition, individual elements have to be blended into a balanced unity. This starts with the initial arrangement of flowers and still-life objects. He likes to surround himself with great variety and builds himself a

109

'jungle' of flowers, pots, plates, bowls and baskets, spread out over a large table. He experiments with lighting, trying out spot lamps, candles or daylight to bring out the intensity of the colours. Any studio arrangement has to be exciting and hold surprises, so spontaneity is allowed a role in the grouping. Eventually 'no more excuses are possible' and Paul makes a start.

Paul's first step is to stare at the arrangement. These staring sessions, as he calls them, are his way of avoiding the obvious. The more he stares the more he discovers, sometimes seeing something as if for the first time. He is often surprised by the intricacies of shape and colour that would be missed by a mere glance. A challenge begins to evolve as to how to untangle the complexity. At this stage Paul says he usually has a panic attack: 'If I don't, I know it will be a boring picture.'

PAINTING

Paul always paints standing up as this allows him to use more dynamic brush work and put all his energy into the picture. He starts while staring, often with a few dots of colour, visualizing points in space. These small marks made with the point of the brush develop into chain-dot lines to establish negative shapes,

Outdoor painting equipment
Paul likes to be prepared, and when working outdoors uses an easel that holds a large board modified with holes into which he can slot palettes and a water container

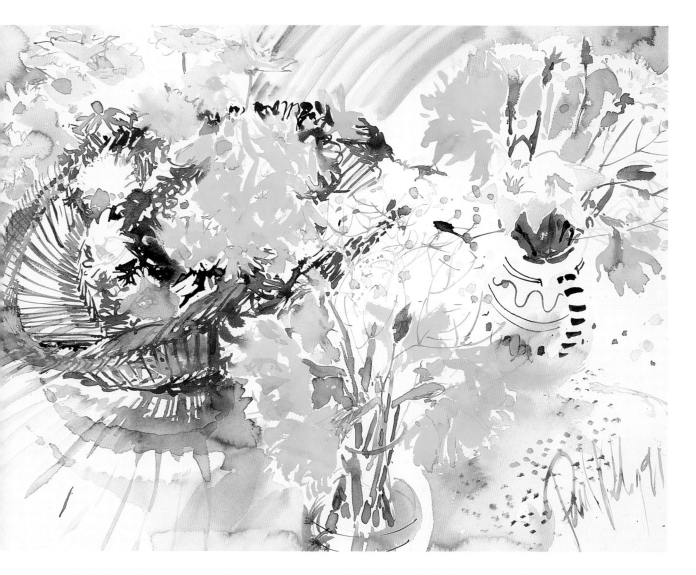

and define the structure of overlapping edges. Paul constantly adjusts this interlocking network of spaces and forms. This is an occasion where he might make a separate study. 'Then I go for the cleanest, brightest primary colours, especially yellows and reds.' The daffodils in *Daffodils with Basket*, for example, are kept very simple to show off their pure colour.

Since Paul has to establish the colours as purely as possible it is convenient to do so while palettes, brushes and water are at their cleanest. These colours form the keynote of the painting, the focal point around which the rest of the picture

Daffodils with Basket
560 × 760 mm (22 × 30 in)
In this explosive composition Paul uses a series of radiating lines from the basket and its shadow to set up a revolving movement. A successful composition like this results from forging a balance between the initial intention and the developing painting. Although the spatial structure of this grouping of flowers, vases and wicker basket is extremely complicated it is still painted with spontaneity. The painting must be as startling, as fresh as the subject itself.

Staring sessions prior to painting allow Paul to grasp a composition in his mind's eye, but in a way that remains open to what might eventually happen on the paper. Although he started with a brush, this painting was finished with a cigarette butt, used to produce the textured marks in the bottom right-hand corner!

Study for Spring Bouquet
560 × 760 mm (22 × 30 in)
Paul has a theory about
drawing. He does not like the
normal English usage of the
word, which to him is too
suggestive of placing a pencil
line around the edge of
something. He prefers the
French word 'dessin' or design.
Designing is a better way of
describing his drawing
process, which is concerned
with organizing the space and
the composition of a painting,
something he usually does
with a brush and colour

revolves. The darkest tones are usually established early on too. This is done with total confidence as he does not plan to go back over them. Paul dislikes too many layers of colour in shadows as it robs the paint of its transparency, producing what he calls a 'dead density of pigment'.

Paul tries to find ways of painting objects without painting them! For example he might paint a leaf by establishing the shadows on each side of it. In the *Study for Spring Bouquet* (above) he demonstrates how to create an object by painting its effect on the background: 'The jug is not painted at all, just a tone here and there and a touch of decoration, yet it's solid.' The application of this approach is clear in the finished painting *Spring Bouquet*.

Finally certain areas of a painting might be softened by sponging down with clean water or they might be washed over with more paint. This is done to unify the many diverse marks, to create depth and to avoid

the picture being a myriad of specks like a view through a kaleidoscope. Any additional painting like this is done with great passion and vigour, otherwise it can easily degenerate into 'fiddling'. It is very easy to overwork a painting and lose the sense of spontaneity.

Paul does not think of the painting as 'finished' in the conventional sense of the word at all. Each painting is part of a continuum exploring a fragment of nature. He simply stops painting when he has made a statement about the fragment before him. Occasionally after leaving the picture for a while an irritation might develop at something unresolved, and a few minutes of reworking are required. A painting session is about three hours and he rarely works on more than one painting at a time, as each becomes his entire 'world' while he is painting it: 'It's like a book that is totally absorbing. It's difficult to chop and change and maintain enthusiasm.'

Spring Bouquet
560 × 760 mm (22 × 30 in)
In order to create a bright
spring atmosphere Paul left a
large proportion of white
paper exposed. The pots are a
good example of 'negative'
painting and the flowers
exhibit different 'personalities'.
The lilies at the top are
painted in a naive way to
emphasize their startling
fragility. The daffodils are
treated more naturalistically,
with simple broad strokes

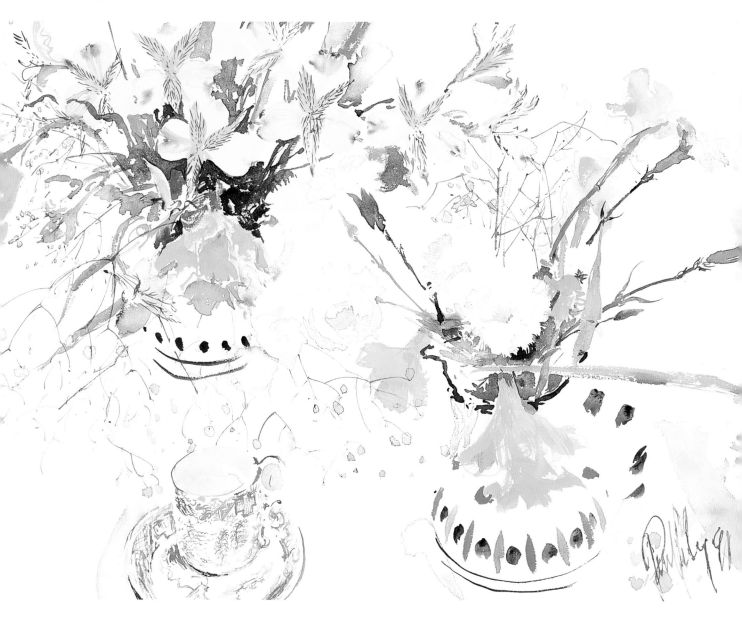

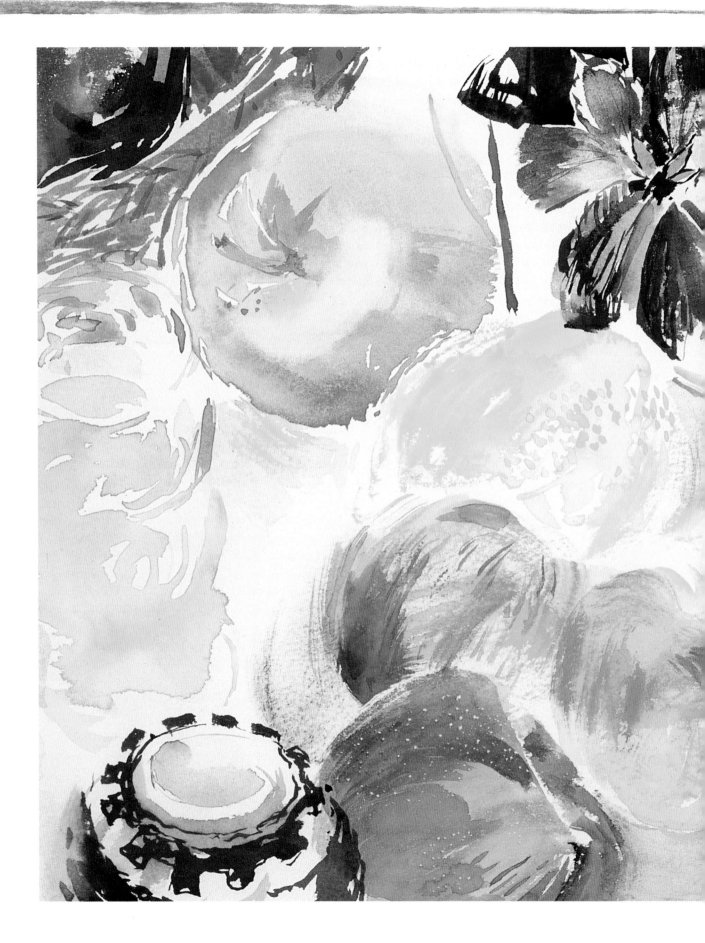

Peaches with Chicks

280 × 380 mm (11 × 15 in)
Studying a still life is an
exercise in trying to discover a
new way of seeing and
painting familiar objects, as if
for the first time. Here Paul
assembled a mixture of
man-made decoration, the base
of a painted pitcher and
natural forms. The painting is
a celebration of colour and
simplicity and a multi-
textural exercise involving
glass, ceramics, fruit and flowers

PRACTICE MAKES PERFECT

Just as a musician develops dexterity by practising scales, the painter can develop his or her skills in similar fashion. You can learn how to handle a brush, how to control its tip and body and exploit all its potential. But other skills must be worked at too, especially observation. Paul draws regularly with pencils, pens and a brush. He often works from the figure because it is such a good form of practice. Nearly everyone can recognize incorrect figure drawings whereas only a botanical expert may spot a poor flower drawing.

Paul also makes small colour studies of flowers and still lifes, especially if it is a species of flower that he has not painted before. These are part of the process of learning to 'see' the subject, unravel its complexity and work out the sequence of operations needed to paint it in an unhindered fashion. His advice is to search the subject constantly for its peculiarity of form and avoid habitual rendering at all cost. Most importantly you have to find a way of conveying the qualities of the subject without overstating them. Look at the foreground of *Peaches with Chicks* (left), and the way that Paul has treated the peaches themselves. You must select the right visual clues to create just enough impact, but leave enough room for the viewer to become involved in the painting and take part in its unravelling.

MASTERCLASS
with Leslie Worth

Leslie Worth's lifelong passion for painting started as a child. He has early recollections of visiting the Plymouth City Art Gallery where he was bowled over by the paintings of Charles Britton, a West Country artist. These paintings of moorland and seascapes 'were almost like icons' to him and fuelled his first attempts at serious painting. Later, as an art student in London, his interest in watercolour was aroused by viewing reproductions of paintings by the English watercolour school artists such as Cotman, Bonnington and Turner. In fact 'everything was a revelation' and he developed a strong admiration for a host of diverse painters.

Initially Leslie worked largely in oil paint and often in conjunction with figure subjects. However, he began to discover that watercolour seemed to have a special character that suited what he wanted to say, and spent increasingly more time painting watercolours of figures, landscapes and allegorical subjects. Leslie has always responded to the directness of watercolour, how it can be put down simply and naturally with no fuss. He enjoys the quick decisions it demands and the way that it can convey what he calls 'a sense of suspended animation', a sudden change in the light or a gust of wind caught and held with a transparent wash.

Leslie has always been nervous about being pigeon-holed as a watercolourist. He feels that the term 'watercolourist' is sometimes manipulated to relegate the medium to the second division, as if it is a minor relation of grander materials. For him watercolour is a medium of great range and potency, with its own language and *raison d'être*.

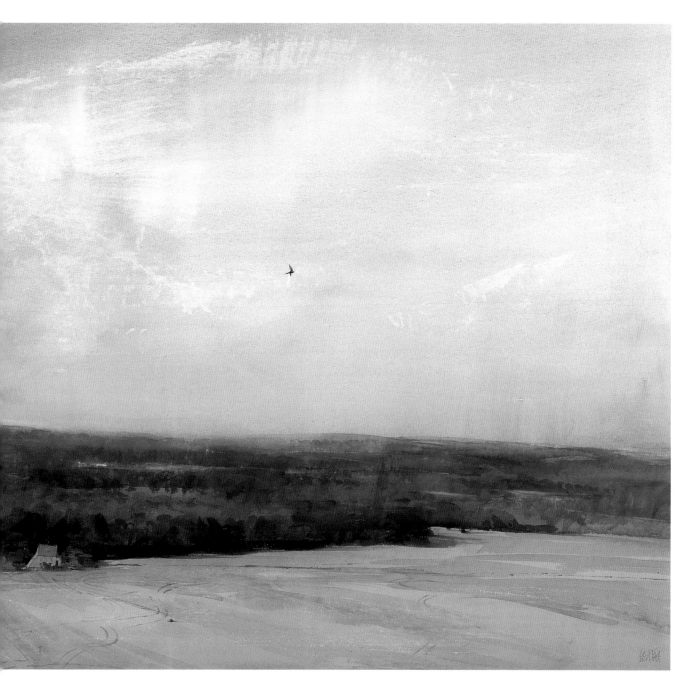

Yellow House Below the Hog's Back

510 × 745 mm (20 × 29¼ in)
This distant view was painted on the spot. Direct observation, memory, previous drawings and paintings, and sheer invention are all part of the total equation. The colours in the sky relate subtly to those in other areas of the painting: Yellow Ochre merges into the lower sky, while pale blue and violet from the rest of the sky filter into the colours of the far and middle distance

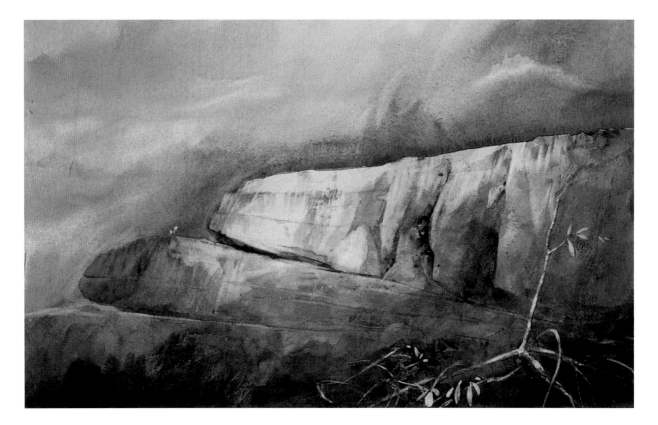

Nourlangie

225 × 280 mm (9 × 11 in)
This small painting evokes a sense of massive monumental scale. The tiny figures, dwarfed by the huge rocks on which they perch, are further diminished by the dramatic placement of branches in the foreground. These opaque, sun-bleached branches thrust towards the viewer, pushing the rocks and the figures further and further back from the picture plane. The particular qualities of light and space in such places always captivate Leslie when he is travelling, and especially the way that the light and the shadows create moods in the landscape. There is a mood of tension in the atmosphere here, caused partly by a contrast of cool blues and greens with the soft warm light. The rounded richness of the illuminated rocks also contrasts strikingly with the stark skeletal branches. The painting was done outdoors in great heat and required lots of water to keep the paper and colours moist enough to blend together in the sky and shadow areas. Colours were also built up with layers of washes, and finally opaque colour was added for the foreground

SUBJECTS

Nourlangie was painted on a visit to Australia and not only explores a colourful and dramatic sky but also the dramatic scale of the rocks. This painting measures only 225 × 280 mm (9 × 11 in) and yet conveys a spirit of the vastness of the natural world. Leslie is more concerned with 'moods in nature rather than places', though it is often specific places that spark off initial ideas, whether at home or abroad. He hates wandering around looking for a good subject and believes that they do not exist as such. Usually a subject finds him, often as a result of some initial encounter in familiar surroundings, such as a bird darting across his path. Ideas often come to him while he is not actually looking for them – while walking the dog or watching television, for example. In general, such involuntary subjects usually turn out to be the best.

Leslie has no 'favourite' subjects, finding all are equally difficult to paint. He believes that the problems are not actually found in the subject but in artists themselves. For him, whatever the view, the theme or the idea the difficulty is to realize his own ideas directly, economically and without compromise and 'of course I fail!'

Self-portrait
560 × 405 mm (22 × 16 in)
Although most of Leslie's watercolours are rooted in the landscape, he also paints figures and portraits, including powerful self-portraits such as this one. Built up over a number of sessions the painting scrutinizes the artist himself and the nature of light and shade. Broad, sweeping washes in the background are contrasted with the highly developed facial details. Cool and warm colour modulations dapple the figure; light is placed against dark, and dark against light with great sensitivity

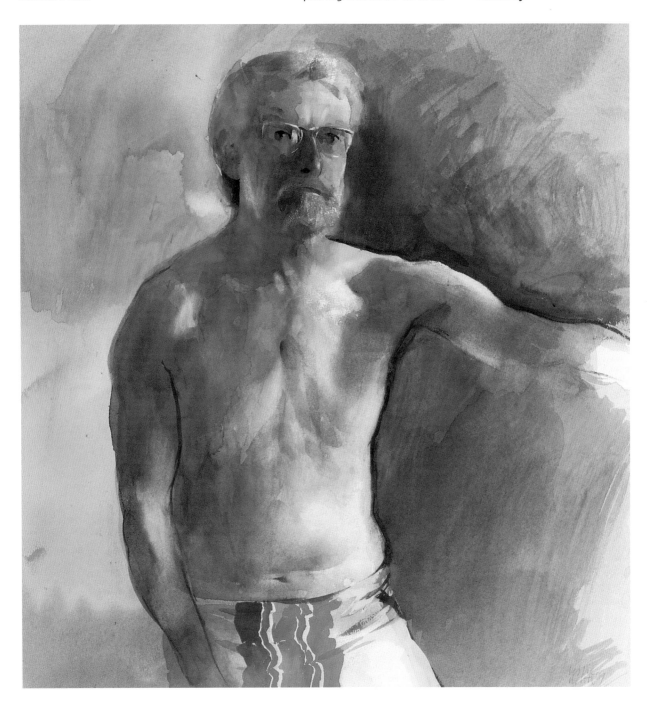

Cold Day On
The Downs

255 × 355 mm (10 × 14 in)
The Downs near Leslie's home
in Epsom, Surrey, provide a
continual source of
ever-changing subject matter
ideally suited to watercolour.
The paper was dampened in
advance to create the foggy,
misty blue-grey sky and
blurred trees of this snow
scene. The ability to evoke
atmosphere with such simple
means (there is more paper
than paint in this
watercolour!) is one of the
great strengths of watercolour

PAINTING LIGHT

At heart Leslie feels that the whole process of finding a subject is a mysterious one involving mental alertness and sensitivity to external stimuli such as qualities of light. Many of his paintings are rooted in the landscape because watercolour has such an affinity with light effects. The transparency or opacity can be varied to suggest different atmospheric properties and create luminous translucent shadows. Forms can be fluidly merged together or crisply contrasted with ease. In *Cold Day on the Downs* and *Hot Day at Lussan* the light and colour of the sky sets the mood for the rest of the painting. Since the sky is the main source of light in a landscape painting, whether or not you can see the sun, it 'governs the entire weight' of the picture.

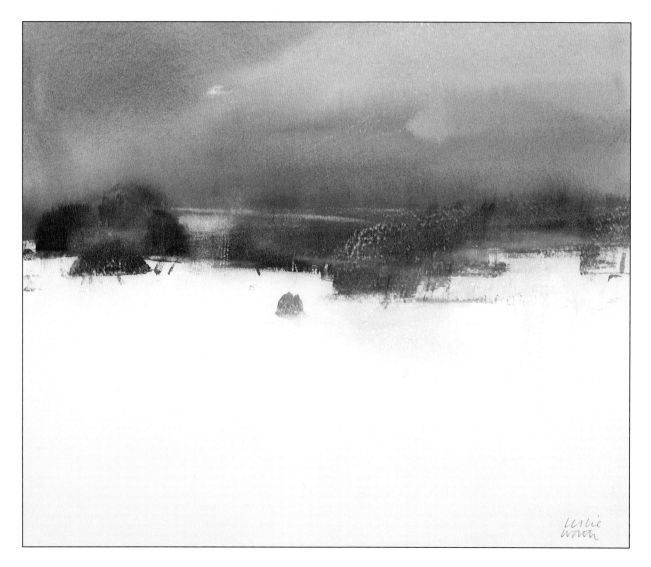

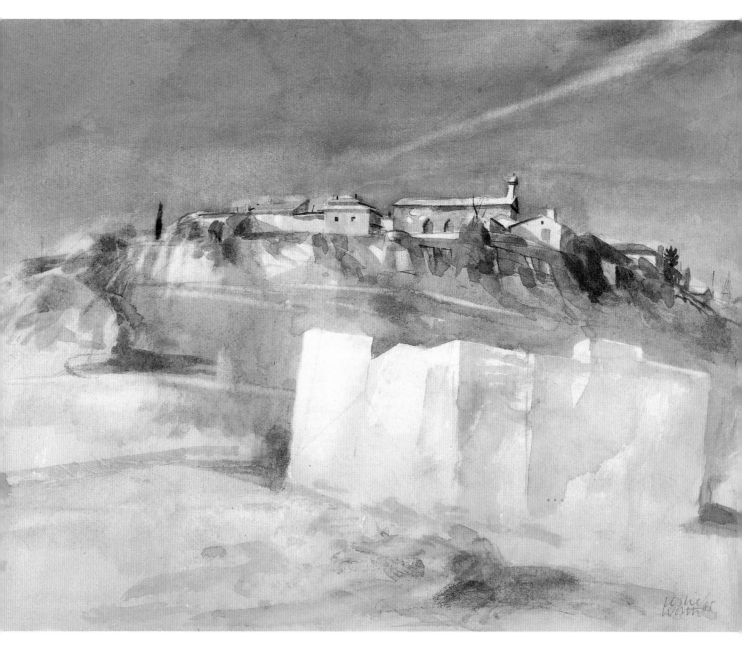

Hot Day at Lussan

225×265 mm $(9 \times 10\frac{1}{2}$ in$)$

Painting landscapes involves a lot more than recording topographical features. It is the way that these features, or indeed whole places, are transformed under different conditions that make landscapes such interesting subjects. Compare the hot, sandy, feeling in this watercolour with the freezing conditions in Cold Day On The Downs. *Different techniques may also be called for because of the prevailing conditions. It is difficult to paint outdoors in extreme heat because the watercolour dries so quickly, and impossible to paint in extreme cold if colours start to freeze. Leslie adapts to the conditions and turns them into advantages. Here the paint dried quickly, allowing him to work rapidly with bold, positive brush strokes. In places these are overlapped to build up shadows. The underlying ochre washes of the middle distance are hardly developed in the foreground, keeping it simple and retaining the immediacy of the painting*

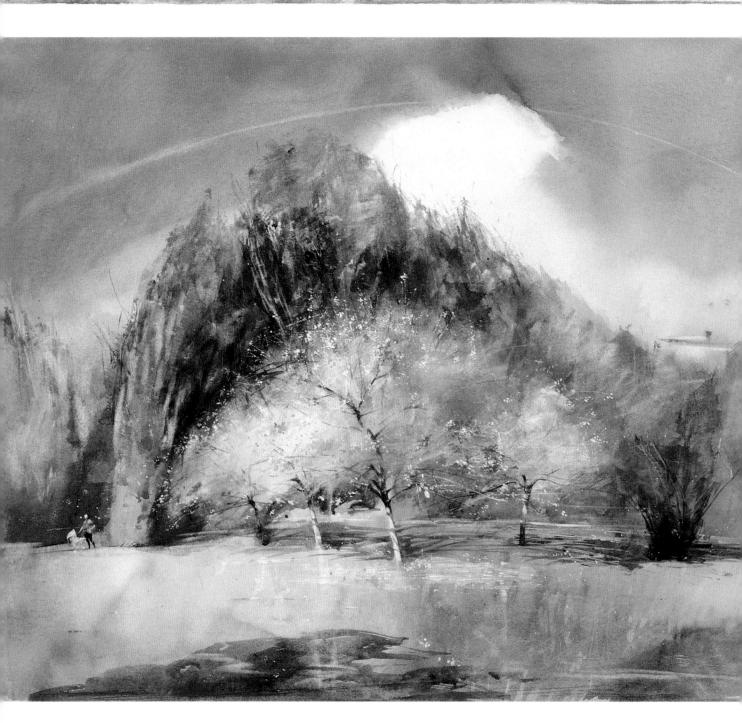

Spring In The Park

510 × 535 mm (20 × 21 in)

No matter how well you know a particular subject, such as a familiar view in a park, the onset of spring brings new surprises. In this painting a blossoming tree is placed right in the centre for maximum impact. Brightly illuminated, it presented a wonderful opportunity to explore qualities of translucency and opacity, with watercolour and gouache. The shadows stretching away beneath the trees create an unusual and intriguing sense of space behind them. The chance of a potential subject may present itself at any time and you have to be alert and responsive to take advantage of it

FOCUS

Within the composition of his paintings Leslie often singles out an image for intense observation, such as the blossoming tree in *Spring In The Park* (opposite). Here our attention is focused on a specific quality of light. The blossoming tree is made transparent by light passing through it towards us so that it stands out, illuminated against the dark shadowed side of a stand of taller trees. We also focus in on the harmony of shapes in the painting, how the arc of the blossoming tree echoes the arcs of the stand of trees, the cloud and the vapour trail behind it. Leslie remains constantly alert to this kind of potential in an image.

DRAWING

The shelves in Leslie's studio are stacked high with sketchbooks. He has always carried one around with him and his collection has evolved into a vast visual diary. Drawing as a habit heightens perception and develops an intensity of observation. Leslie believes that you also have to practise drawing to develop an economy of style, to learn how to make every mark mean something. In addition to sketchbook work he also makes more 'thorough' drawings on individual sheets of paper. Some drawings are elaborate but some are almost diagrammatic information sheets, maybe even covered in written notes. However slight or elaborate they may be they are drawn as ends in themselves and not really as preliminary studies. The accumulated drawings of years and years of work form a reservoir of clues for different subjects that Leslie can dip into at any time. Drawing is not only useful as a discipline to train hand and eye but is also excellent for revitalizing ideas. However, he feels strongly that ultimately, regardless of drawings made, 'one has to take the plunge and paint, and risk failing'.

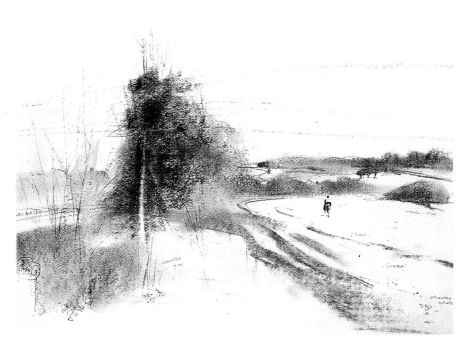

Drawing for Winter Day
On The Downs
305 × 405 mm (12 × 16 in)
This is one of the many drawings that Leslie has made on The Downs in Surrey. He makes such drawings as an end in themselves, although he finds that they often lead towards a painting

PAINTING MATERIALS

Leslie tends to paint with tube watercolours, usually artists' quality colours. He also paints with gouache, sometimes on tinted paper or plain brown wrapping paper he has prepared with gelatin size. A typical palette might comprise Chinese or Zinc White, Raw Sienna, Burnt Sienna, Aureolin, Cadmium Orange, Cadmium Red, Light Red, Raw Umber, Sepia, Viridian, Turquoise, Prussian Blue, Ultramarine, Cobalt, Violet and occasionally Black. This really represents the widest range of choices and Leslie certainly does not use all the colours all the time, 'anymore than a pianist would use all the keys on the piano'. He finds it most productive to work within a given harmonic range of perhaps four or five of these colours.

He favours an old plate or a piece of white board for a palette (left). When painting outdoors Leslie will use an easel as long as it is adequately rigid and portable. Brushes are selected by the criterion that they make the 'appropriate' mark for the particular painting. They range from 75 mm (3 in) flat brushes to fine Number 1 round sables. He finds modern inexpensive synthetic brushes perfectly adequate though he has a large collection of sable and other types to choose from.

PAPER

Leslie believes in painting on anything that is suitable or can be rendered suitable. Ordinary brown wrapping paper can make an ideal watercolour paper. It is stretched and then prepared by brushing on an application of gelatin size to make it less absorbent. This can be bought ready-prepared in a small bottle.

He is particular about the special watercolour paper that he buys, disliking rough papers and many other conventional watercolour papers. He feels that too many of these have a surface texture which is far too dominant and impose too much of their own character on the painting. He favours 'a heavy paper with a discreet, anonymous surface'. Leslie actually has a small collection of paper that most artists would ensure remained in a pristine, unpainted state. They are sheets of the famous 'Whatman Turkey Mill' watercolour paper handmade and watermarked in 1834, and favoured by many legendary artists of the English watercolour school. *Aftermath* (opposite) was painted on a sheet of this paper after Leslie watched the television reports about the oil fires in Kuwait in 1991. The year of the paper's manufacture was the year Turner made his studies for the burning of the Houses of Parliament in London.

PAINTING: PREPARATION AND PROCESS

Leslie's first step is to attempt to realize the idea in his mind before committing it to paper: 'In a sense it's all memory, recalling accumulated experience to reinvent the subject before you.' He likes to paint directly from the subject, but also paints from his imagination or from memory. He has trained his memory by practising looking at a subject and then shutting his eyes and reciting to himself what he has seen. He tries to visualize exact shapes, tonal patterns and colour relationships in detail. Then he will look again and repeat the process, even tracing out an image with his fingertip on his thigh, trying to recall the total experience.

Palette and brush
White, coated chipboard, sawn from a piece of old furniture, makes an ideal watercolour palette. Leslie finds that its surface looks very similar to paper when watercolours are mixed on it. This means that the colour mixed on the palette will look the same when it is washed onto his paper

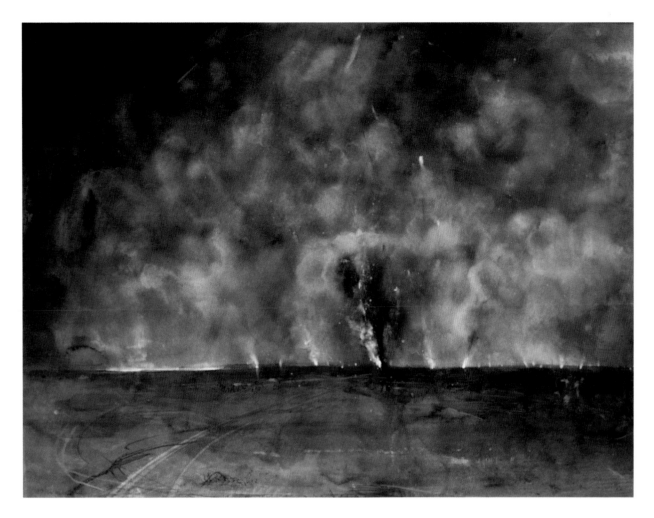

Aftermath

455 × 605 mm ($18 × 23\frac{3}{4}$ in)
This powerful depiction of burning oil wells in Kuwait was sparked off by television coverage. Leslie often makes drawings and paintings in response to major world events brought into his living room via television and satellite technology. In the 1960s he made a sequence of paintings based on the Apollo expeditions and moon landings. This painting features a very different palette to that used on many other landscape paintings he was working on at the same time and is based primarily on brown, indigo and red. The dense smoke-filled sky was invented, responding to the effects created by applying colour and lifting it off, gradually building up the soft, smoky patterns. Maximum contrast of light and dark is reserved for the horizon line, creating an illusion of bright, intense, white lights. Thick red watercolour and a touch of yellow add to the excitement. Leslie gives a great sense of movement to the sky by repeating the smoke shapes billowing upwards from the low horizon

Gold Ore Crushing Mill, Bendigo, Victoria, Australia
535 × 570 mm (21 × 22½ in)
Leslie enjoys the way that watercolour behaves, as well as its descriptive potential. Here he has concentrated on building up layers of paint to express the richness of light and colour. He also conveys the strange mystery of the disused mill, standing alone amidst the undergrowth In all his paintings he tries to achieve harmony between the various elements, to create a powerful atmosphere

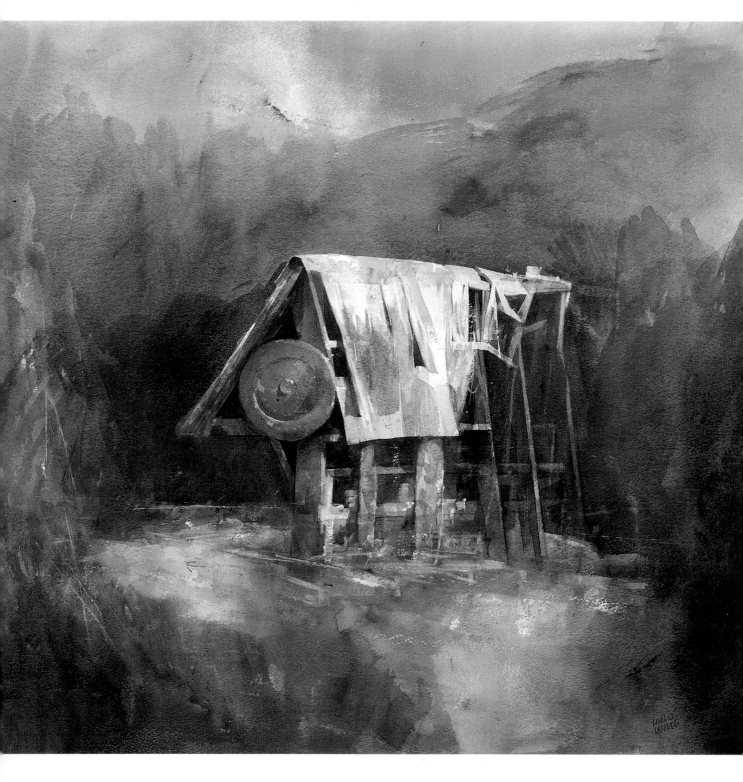

Girl and Dog
90 × 115 mm $(3\frac{1}{2} \times 4\frac{1}{2}$ in$)$
This tiny painting of a girl and her dog running along the beach demonstrates a tremendous mastery of watercolour. Painting successfully on a range of scales requires great experience, because what works on a large scale does not necessarily work in miniature. Here, the smallest flick of a sable brush becomes a dog. Another fascinating aspect of this watercolour is the unusual viewpoint, looking down. Finally, despite the small area, there is enough variety of colour and tone in the sea to suggest a great expanse of water

Leslie always arranges his materials carefully and reviews any related sketches or drawings. When working in the studio, he positions himself so that good daylight from the left rakes across the paper in front of him. As he paints right-handed, no shadows from his hand or arm are cast across the paper. He makes use of overhead fluorescent lights when daylight is poor or at night. This kind of organization is essential for Leslie, otherwise he says that painting can be like 'trying to play the cello in an armchair'.

A painting is started in the most ambitious style, Leslie striving to encapsulate the total essence of the subject all at once. There is no underdrawing; just direct painting with bold quick actions. He tries to avoid what he calls 'isolated episodes' developing as everything must work together. After the initial washes have been applied the next stage is usually one of developing the 'resolution' of the painting, working in more detail but always in relation to the whole, every touch serving the larger picture. Balance, tension, colour, expression, tonal contrast and all the other elements of painting have to be conjured with together simultaneously. Then, to make it even more of a challenge, this complexity must also be simplified to heighten and enhance the drama of the painting.

Paintings might take four or five days to complete or they may take a few minutes. Leslie believes that you cannot equate length of working time with quality or intensity of vision. Similarly a moment of excitement or a dramatic reaction to something will not necessarily produce a good painting. This complexity and the almost 'unfathomable' nature of painting means that every single watercolour is a completely new adventure which is likely to be both frustrating and rewarding: 'It requires a mind that is keen and reflective and can envisage the final result – but not too well, for one must be aware of what is happening beneath the brush and be prepared to take advantage of the unpremeditated development' (from Leslie Worth's book *The Practice of Watercolour Painting*: Pitman, London; Watson-Guptill, New York, 1977).

Artists' Biographies

Kim Atkinson studied painting at Cheltenham School of Art and natural history illustration at the Royal College of Art in London. She travels abroad frequently, drawing and painting, and has shown her work regularly in the UK. She recently worked with the Artists for Nature Foundation in Poland. She lives and has her studio on Barsdey Island, off the coast of North Wales. Her work was featured in the *Encyclopedia Of Drawing Techniques* (Quarto, 1987).

Adrian Berg has a studio in Hove, Sussex. He studied at St Martin's School of Art, Chelsea School of Art and the Royal College of Art in London. His paintings are represented in major international collections including the British Museum and the Tate Gallery in London, the European Parliament and the Tokyo Metropolitan Art Museum. He has had numerous one-man exhibitions in Britain, Europe, the USA and Canada since the 1960s. Several interviews and features have been written about his paintings in books, exhibition catalogues and magazines.

John Blockley has studios in Gloucestershire and Derbyshire and his paintings often reflect their landscapes, but he enjoys working in a variety of locations. He is President of the Pastel Society of Great Britain, and a member of the Royal Institute of Painters in Watercolours and of the New English Art Club. He exhibits frequently in the UK, particularly in group shows, and has also exhibited in the USA and Germany. His publications include two titles in the HarperCollins *Learn to Paint* series – *Pastels* (1980) and *Flowers in Pastel* (1992) – and his book *Watercolour Interpretations* was published by Collins in 1987.

Cherryl Fountain has her studio in Sheldwich Lees, near Faversham in Kent. She studied painting at Reading University and the Royal Academy in London. She was awarded an Italian Government bursary to paint in Perugia, Italy, and also received the Richard Ford award to paint in Spain. She paints regularly in well-known English gardens and has undertaken commissions for the National Trust's Foundation for Art. She has paintings in private and public collections, including the Royal Museum in Canterbury. Her paintings were featured in the *Encyclopedia of Watercolour Techniques* (Guild) and *Practical Watercolour Techniques* (Tiger Books).

Lesley Giles lives and has a studio in London. She studied painting at Goldsmiths College, London, and the Royal College of Art. She exhibits her work regularly in the UK and travels extensively around Europe to find subjects for her paintings. Her oil paintings and watercolours are in many private collections and her work was featured in *The Challenge of Landscape Painting*, published by HarperCollins in 1990.

Charles Reid lives and works in the USA. He is well known not only for his painting but also as an author of numerous art instruction books. He has made several instructional videos about painting and he also works as a professional illustrator. He is an elected member of both the United States National Academy of Design and the Century Association, and his paintings are included in many collections.

Paul Riley paints, makes prints and sculpture, and runs his own teaching establishment at Coombe Farm Studios in Dittisham, Devon. He has exhibited his work and lectured internationally, and is represented by the Chris Beetles Gallery, London. His work has been reproduced in a number of art books and magazines and he is the author of two books, *Flower Painting* (Broadcast Books) and *Intimate Landscape* (Element Books).

Leslie Worth studied at Bideford and Plymouth Schools of Art in Devon and at the Royal College of Art in London. He lives in Surrey and regularly travels abroad to paint. He has had several exhibitions at Agnews and other London galleries and his work is represented in a number of public and private collections around the world. He is the President of the Royal Watercolour Society and Keeper to the Royal Society of British Artists. He has taught drawing and painting for many years and was the author of *The Practice of Watercolour Painting* (Pitman, 1977).